NON-WESTERN ART
A Brief Guide

LYNN MACKENZIE
College of DuPage

Prentice Hall, Englewood Cliffs, New Jersey 07632

Library of Congress Cataloging-in-Publication Data

Mackenzie, Lynn.
 Non-Western art : a brief guide / Lynn Mackenzie.
 p. cm.
 Includes bibliographical references (p.) and index.
 ISBN 0-13-104894-5
 1. Art—History. I. Title.
N5300.M23 1995
709—dc20

94-44273
CIP

Publisher: *Bud Therien*
Editorial assistant: *Lee Mamunes*
Production editor: *Jean Lapidus*
Photo editor: *Lorinda Morris-Nantz*
Photo researcher: *Dallas Chang*
Manufacturing buyer: *Bob Anderson*
Copy editor: *Maria Caruso*
Cover design: *Wendy Alling Judy*

 © 1995 by Prentice-Hall, Inc.
A Simon & Schuster Company
Englewood Cliffs, New Jersey 07632

Printed in the United States of America
10 9 8 7 6 5

ISBN 0-13-104894-5

PRENTICE-HALL INTERNATIONAL (UK) LIMITED, *London*
PRENTICE-HALL OF AUSTRALIA PTY. LIMITED, *Sydney*
PRENTICE-HALL CANADA INC., *Toronto*
PRENTICE-HALL HISPANOAMERICANA, S.A., *Mexico*
PRENTICE-HALL OF INDIA PRIVATE LIMITED, *New Delhi*
PRENTICE-HALL OF JAPAN, INC., *Tokyo*
SIMON & SCHUSTER ASIA PTE. LTD., *Singapore*
EDITORA PRENTICE-HALL DO BRASIL, LTDA., *Rio de Janeiro*

Contents

Preface

Non-Western Art: A Brief Guide was conceived as a supplemental text for art history, art appreciation, and humanities courses. It is an outline for a reader's first encounter with an immensely varied and complex topic. This little book is intended to spark an interest in the subject and was not designed for an in-depth study or as a text in specialty courses. Discussions focus on the visual qualities that arose from the worldviews embraced by people living in Africa, Asia, Oceania, and the Americas. The material is organized geographically, beginning in Africa and traveling east to the Americas. With the exception of China, where the dynastic sequences can confound a first appreciation of the art, the examples are disposed in chronological order. Media include painting, sculpture, ceramics, fiber arts, printmaking, and architecture.

The premise of the book is that art encapsulates the attitudes of the people who made and used it. Contextual information, drawing on history, society, religious beliefs, and ethical attitudes, illuminates the factors that guided the choices artists made when they fashioned works of art. Attention is given to descriptions of the individual works so that readers will have a starting point in articulating what they see. The goal is to make audiences feel comfortable with the visual expressions created within the world community.

Considerable disagreement exists concerning the use of the word "Non-Western;" even the spelling is a point of contention. The word does not imply that the visual expressions lack something or that they are opposed to "Western" art. "Non-Western" has no pejorative implications, unless we feel that "nonrepresentational" paintings are demeaned by their salient adjectives also. It is merely a term that reflects our growing awareness of the richness and diversity of world culture. Considerable disagreement regarding appro-

priate subjects for a Non-Western study exists as well. In light of the fact that Non-Western art can include most of the world, topics are narrowed to those familiar in the discipline of art history and works of art that invite comparisons.

In descriptions of works of art, "right" and "left" refer to the right and left sides of the illustrations, unless otherwise indicated in the text. Chinese words use pinyin spelling. No diacritical marks are used. Dates indicated B.C.E. (Before Current Era) correspond to B.C. All other dates are of the current era (A.D.).

For assistance in this project I extend my thanks to Bud Therien, my editor at Prentice Hall, who suggested the project; Jean Lapidus, Production Editor; Ed Kies, Dean of the Humanities Division at the College of DuPage, for his support in this project and the original long version, forthcoming from Prentice Hall; the reviewers for their passionate comments; Max Sinclair, for reading the proof sheets; and, my students for their perceptive questions. A special note of appreciation to Dallas Chang, unfailing photo researcher, for securing the illustrations. To Bruce and Kate, my love and gratitude for your patience.

Lynn Mackenzie
Glen Ellyn, Illinois

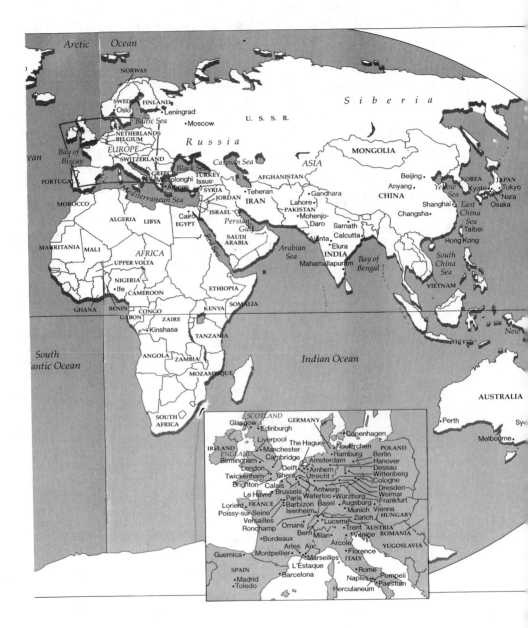

Arctic Ocean

NORWAY

SWEDEN FINLAND
Oslo Leningrad
Baltic Sea •Moscow

U. S. S. R.

S i b e r i a

NETHERLANDS
BELGIUM
EUROPE R u s s i a
SWITZERLAND

Bay of
Biscay

ean

Caspian Sea A S I A

MONGOLIA

PORTUGAL
GREECE
Missolonghi Issus
•Athens

Black Sea
TURKEY
SYRIA
JORDAN
ISRAEL

AFGHANISTAN

•Teheran

IRAN

Mediterranean Sea

MOROCCO

•Gandhara

Beijing •
Anyang •
CHINA

Yellow
Sea

KOREA
Kyoto
Nara

JAPAN
Tokyo

Lahore •
PAKISTAN
•Mohenjo-
Daro

Shanghai •

Changsha •

East
China
Sea

Taibei

Osaka

ALGERIA LIBYA

Cairo
EGYPT

Persian
Gulf

MAURITANIA MALI

AFRICA

SAUDI
ARABIA

Red Sea

UPPER VOLTA

Sarnath
•Calcutta
Ajanta
•Elura

Arabian
Sea
Mahamallapuram

INDIA
Bay of
Bengal

South
China
Sea

Hong Kong

NIGERIA
•Ife CAMEROON

ETHIOPIA

VIETNAM

GHANA
BENIN
GABON CONGO
ZAIRE
Kinshasa

KENYA

SOMALIA

New

TANZANIA

South
antic Ocean

ANGOLA ZAMBIA

MOZAMBIQUE

Indian Ocean

AUSTRALIA

•Perth

Sy

Melbourne •

SOUTH
AFRICA

SCOTLAND
Glasgow
•Edinburgh

GERMANY

•Copenhagen

Liverpool
IRELAND
ENGLAND
Birmingham

The Hague
Manchester
Cambridge

•Neukirchen
•Hamburg
Amsterdam

POLAND
Berlin
Hanover
Dessau
Wittenberg

London
Twickenham
Brighton Calais
Le Havre
Lorient FRANCE
Poissy-sur-Seine
Versailles
Ronchamp Ornans

Delft
Ghent
Utrecht
Antwerp
Brussels Waterloo
Paris
Barbizon Basel
Isenheim

Arnhem

•Würzburg
Augsburg
•Munich
Zürich
•Lucerne
•Trent

Cologne
Dresden
Weimar
Frankfurt

Vienna
HUNGARY

Bern Milan •
•Bordeaux
Arles Aix
Montpellier •
Guernica •
L'Estaque

Arcole
•Venice

AUSTRIA
ROMANIA

•Florence
•Marseilles
ITALY

SPAIN
•Madrid
•Toledo

•Barcelona

YUGOSLAVIA

•Rome
Naples •
•Pompeii
Paestum

Herculaneum

viii

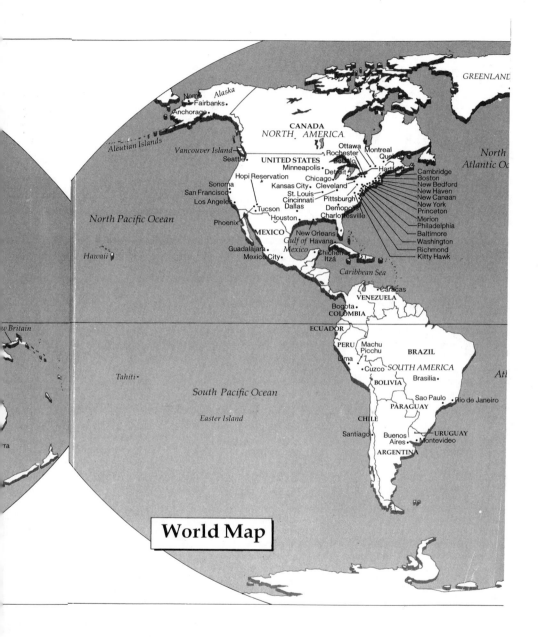

World Map

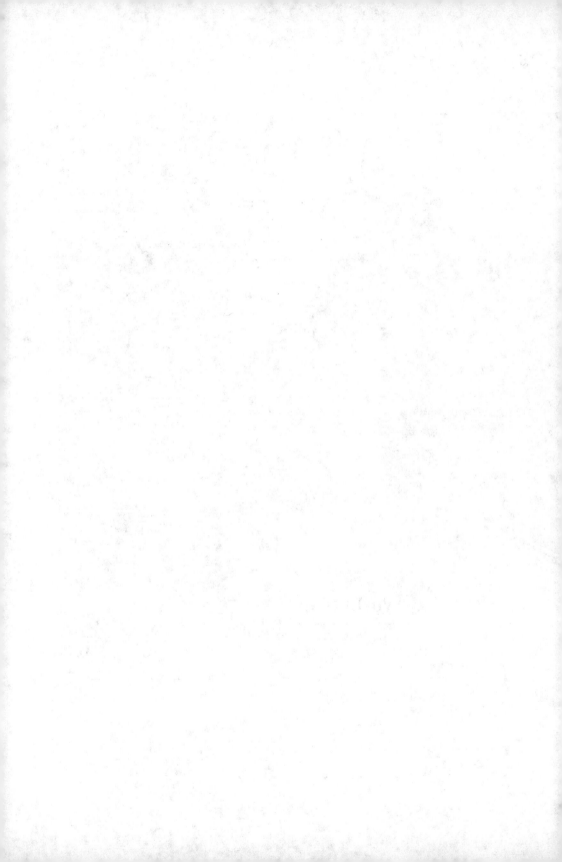

Introduction

We begin with an imaginary stroll through a museum that takes pride in its comprehensive collection of world art. During the tour some people in our group will marvel at the technical virtuosity that transformed white marble into flesh or the skill required to maneuver oil paint into an illusion of miles. Many will feel comfortable in galleries devoted to toga-draped patricians, those where portraits of pensive children hang beside detailed still lifes and resplendent angels materialize on canvas.

Then we enter rooms where blocks of encrusted wood bristle with nails, bronze caldrons swirl with dragons, and statues of four-headed men and ten-armed women fill the cases. At this point the expectations of the group may be challenged by objects whose images, materials, and functions have few counterparts in the previous galleries. Collectively, these works are called Non-Western, a convenient term for cultures that matured independently of the Western tradition, one that originated in ancient Greece and was amplified in Europe. Non-Western art flourished in Africa, Asia, the Americas, and on islands in the Pacific Ocean. By colonization, conquest or commercial exchange with the West, some Non-Western cultures were modified or eliminated. Others are living traditions.

Finely crafted objects, which we are now inclined to label "works of art," have served many purposes in Non-Western communities. First is art for intervention. Sacred objects manipulated unseen forces, providing repositories for supernatural powers and bridges to other dimensions. Ritual specialists had access to such images. For the community at large, viewing the objects was restricted, and encounters were rapturous. Many works had no living human audience because they were created for the dead and sealed in tombs.

Second is art for affiliation. Families, fellowships and, most important, the right to rule, were defined by art. People fashioned objects, buildings and environments that helped organize themselves within the community. Third is art for documentation. Momentous events, accounts of creation, the adventures of deities, culture heroes, and civic leaders, were components of the communal past. Documentary art preserved history, but it rarely found room for the laborer or an ordinary activity. Finally, art was created for aesthetic contemplation. The work stimulated the sense of beauty by appealing to the artistic temperament; it was enjoyable and environmentally enhancing.

The museum setting in which we commenced our study was foreign to the display strategies in Non-Western communities, where the opportunity to experience art was a privilege, as was the right to its possession. Occasions for the display of art were mysterious and celebratory. Rarely was the experience casual like our tour of the galleries. Viewing art was regulated by age, gender, class, and initiation. Commissioning art depended on status, and making art was usually a hereditary profession.

Often the display methods that bring us the worlds of Non-Western art can obscure the objects' original functions. When experiencing works in a museum, our responses are tempered by the silent setting as we view works that were once activated by motion and sound, works that were intentionally disposable, works that, had we lived in the communities where they were created, we never would have been allowed to see. While specialists lament that the museum raises barriers to a full appreciation of Non-Western traditions, any knowledgeable viewer can overcome its obstacles. To the museum we owe the opportunity to experience the variety of world cultures.

Whether it was created in eleventh century China or twentieth century France, art is a storehouse of human experience. Art speaks about relations, the individual to the community, the community to the environment, the seen world to the unseen world. Art is about people, the choices they have made and their attitudes on life. What has motivated people? What was worth their time, energies, and resources? Whom did they revere? What did they fear? Along with dance and drama, music and literature, the visual arts articulate what it means to be human.

1

Africa

The richly textured artistic heritage of Africa offers one of the most rewarding experiences in Non-Western studies. Some works will appear exotic yet oddly familiar because they possess a strikingly modern quality.

We can liken the expansiveness of African art to the immensity of the continent itself, a land so vast that the contiguous United States would fit in the Sahara desert without touching the African coasts. The contrasting terrain, with over one quarter of the land desert and about one tenth dense rainforest, is a metaphor for the stylistic extremes in African art. Sometimes we confront near speaking-likenesses, and at other times a face may be so far removed from the physical world that it undoubtedly records pure idea. African artists were masters at materializing the world of the imagination, creating works of stunning realism alongside those with natural clues that have been purified and rearranged.

Traveling through African art is as challenging as an overland journey across the continent. Our itinerary has three stops in history, the ancient, medieval, and colonial periods. In each epoch the human figure was the principal image; artists attuned to its endless design potential molded limbs into flexible tubes and fractured torsos into hard-edged shards. Realistic anatomy was often irrelevant to artists who delighted in abstraction. Sculpture was a major format for African art. Small scale statues in wood, clay and metal were the norms, while monumental stone sculpture was a localized expression. The nonrepresentational tradition of African fiber arts is outside the scope of our study, but the penchant for surface embellishment will be evident in the sculptural arts.

Because the spiritual and the social dimensions of life are intertwined, the religious and secular aspects of African art are often inseparable. Yet we can identify many works that were created for religious purposes, if by religious we mean that they address an unseen dimension of existence. Indigenous African religions recognize invisible entities, forces of nature and spirits of the dead, which interact with the community of the living. The belief (*animism*) that dynamic energies can dwell in inanimate objects such as stones or statues is a motivating force in the worldviews of people around the globe. In Africa, the spirits of the dead are especially important, and the theme of the ancestral dead appears frequently in art. Alongside the indigenous animist religions are the imported monotheist religions, Christianity and Islam. With its predisposition for flat, overall pattern, Islamic art added a nonrepresentational counterpoint to the figural tradition on the continent.

ANCIENT AFRICA

Beginning as early as 8000 B.C.E. Africans painted pictures on rock surfaces in the Sahara desert. They document a lifeway based on raising cattle and a culture with ritual costumes and ceremonies. Although the tens of thousands of rock paintings have no inscriptions that would explain their meanings, they serve as excellent pictorial records of early life in North Africa.

Nilotic Cultures

We must turn east to the Nile Valley for surviving evidence of Africa's earliest complex civilizations. Collectively, the cultures that prospered along the river are called *Nilotic*. Egypt, in North Africa, was the longest lived of the Nilotic cultures. In the future, archaeologists may discover other civilizations of great antiquity on the continent, but Africa's climate has not been sympathetic to the preservation of artifacts. Political instability and hostile terrain have impeded research in many areas.

Ancient Egypt. Ancient Egyptian artists expended exceptional energies creating works that enabled the spirits of the dead to continue in a life after death. Tombs and statues were dwelling places for the ancestral dead. The funerary statue of Old Kingdom pharaoh Menkaure and his chief queen, Khamerernebty (Fig. 1), recovered from a temple near his tomb, one of the Great Pyramids at Giza, represents the classic ancient Egyptian interpretation of the human body. It is a subtle blend of naturalistic and abstract elements arranged in a deceptively simple composition. This aesthetic sensibility is an underpinning of subsequent continental art. The artist introduced anatomical abstractions by generalizing the bodies to geometric units. For example, the pharaoh's knees are squares and his calves are flat planes with sharp corners. The queen's body, on the other hand, is built of cylinders and spheres. Meaningful geometric shapes, hard–edged for the male and round for the fe-

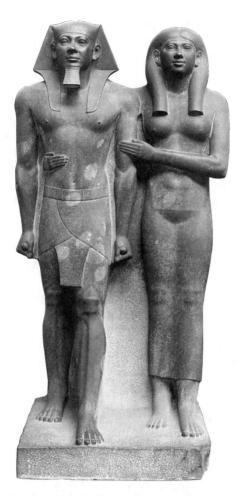

Figure 1 Nilotic (Egypt). Menkaure and
Khamerernebty, ca. 2520 B.C.E.; slate, 56" H.
Courtesy, Museum of Fine Arts, Boston

male, are synthesized into an ideal rendition of people at the prime of life.
The balanced composition isolates the man and woman in an emotional vac-
uum, but the design also suggests equality between the two. The double sym-
metry was possible because the sculptors took liberties with the normal
presentation of women, who were usually shown much smaller than men
and standing with both feet together.

In ancient Egypt, as well as in later cultures on the continent, tradition
was prized, and artists were instructed in correct codes of presentation and
symbolism. Rarely was change pursued aggressively, and we can surmise
that artists did not seek to be conspicuously different from their predeces-

sors. When the occasion was right, however, ancient continental artists were sensitive to the nuances of personality and individual appearance. The Amarna period (1378–1362 B.C.E.) was a brief moment in ancient Egyptian history when exploring such avenues was sanctioned. Pharaoh Akhenaten encouraged experimentation that resulted in a new visual expressiveness.

The tiny ebony head of the pharaoh's mother, Queen Tiy (Fig. 2), reveals the visual and psychological realism of Amarna art. The artist created an imposing image that fused the regal aloofness of Queen Khamerernebty with the realism of an ordinary woman past her prime. The drooping mouth and heavy eyelids, chiseled in deep recesses, make the Tiy head one of the most expressively carved statues from ancient Africa. The arched brow and razor-thin nose introduce an angularity that was absent in the traditional Egyptian statue.

Kingdoms of Kush. Other Nilotic cultures, called collectively the Kingdoms of Kush, were located south of Egypt in Nubia, a geographically desolate terrain in Sudan. From 712/30 to 664 B.C.E. Kushite kings, who considered themselves legitimate heirs to Egypt's glorious past not its conquerors, ruled Egypt. The Nubians' admiration for Egyptian culture is evident in the small portrait sphinx (Fig. 3) of the fourth Kushite pharaoh, Taharqa (died 664 B.C.E.). Although inspired by monumental examples such as the Great Sphinx at Giza, the Kushite work does not copy the ancient models but interprets them in the way European sculpture of the Renaissance was inspired by ancient Roman statues.

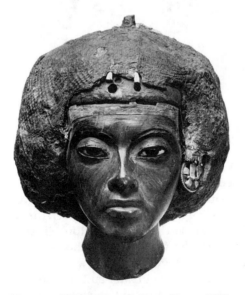

Figure 2 Nilotic (Egypt). Queen Tiy, ca. 1375
B.C.E.; wood, glass paste, gold, paint, 3 3/4" H.
Aegyptisches Museum, Berlin

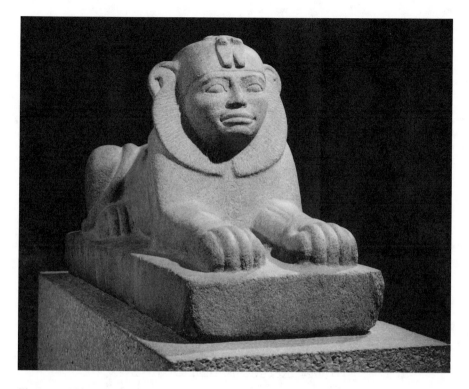

Figure 3 Nilotic (Nubia). Taharqa Sphinx, ca. 680 B.C.E.; granite, 16″ H. British Museum, London

Ethnicity and heightened abstraction set the Taharqa sphinx apart from Egyptian prototypes. When considering the blunt profile, it is apparent that the nose and mouth are carved to the same plane of the stone block. The face is simplified to flat surfaces so that the wide jaw and short chin square the contour into a fleshy cube. The stylized lion's mane is a circular sweep of radiating lines framing the face. Expressively the Nubian sphinx communicates a sense of personal well-being while retaining the traditional meaning of human intelligence commanding animal strength, a recurring theme in African art.

Nok

On the opposite side of the continent in Nigeria, the Nok culture flourished from 500 B.C.E. to 200. Presently it is identified as the oldest artistic tradition in West Africa, although the sophisticated style implies that archaeologists have yet to discover the remains of its predecessors. Little is known about the people who created the clay head in Figure 4. They were skilled farmers and metalworkers, but their history, society, and beliefs remain mysteries.

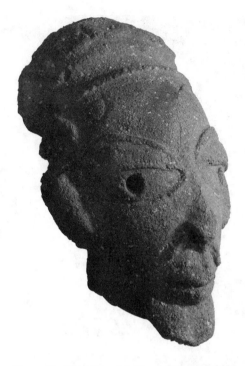

Figure 4 Nok (Nigeria). Head, 500 B.C.E.–200;
clay

Nok sculpture was made of fine red clay, handbuilt with etched and stamped details. Most represent humans, probably individuals of high rank or the ancestral dead. Our example possesses the elongated face and compact silhouette characteristic of the Nok style. The head is a smooth, hollow cylinder with incised lines marking the soaring brows, which typically complete a circle with the deeply marked lower rims. Ordinarily the eyelid bisects this oval, and the pupils are punched through the clay wall. With an economy of means, the anonymous Nok ceramist endowed the figure with wisdom and authority.

MEDIEVAL AFRICA

Gold provided the economic base for the wealthy trading kingdoms of medieval Africa. For over a thousand years, from the seventh century of the current era to the late eighteenth century, a cosmopolitan air pervaded culture on the continent; economic stability encouraged the visual arts. In the world of medieval international commerce, merchants in Mali negotiated between the gold producers in the south and the gold consumers in the north.

Ivory, tin, salt, furs, and humans were also exchanged in the international trade network. Goods were transported in caravans across the Sahara desert to newly founded Cairo for export around the world. Many merchants were Muslims, and the new religion became associated with wealth, prestige, and education.

Islamic Africa

The medieval period in Africa commenced with the arrival of Islam in the seventh century. Muslims brought unifying cultural elements to the continent, the religion itself with its code of social conduct, writing and scholarship, and an architectural style of arches and floral decoration, both of which found their finest outlet in the mosque. A *mosque*, the place of worship where Muslims may offer the obligatory prayers to Allah (meaning "God" in Arabic), was the focal point of medieval Islamic life. The building unified the community through personal veneration performed publicly, and constructing a mosque in a newly converted region of Africa proclaimed affiliation with the international community of Islam.

A typical mosque anywhere in the Islamic world is a rectangular building where prayers are recited in the main space, an internal, open-air courtyard. The essential components of a mosque are few. Every mosque has a wall niche (*mihrab*) on the Mecca side of the building, to orient prayers to the sacred city, and a fountain or pool in the courtyard, where one washes before prayer. Prayer hours are announced from the calling tower (*minaret*), the distant spiral structure topped by a domed pavilion in Figure 5.

We can find some of the world's oldest and finest Islamic buildings, such as the Great Mosque in Cairo (Fig. 5), in Africa. Close ties between North Africa and the Near East ensured that the classic Islamic style flourished in this region. Gently tapering, pointed arches and recessed floral roundels, both motifs anticipating architectural elements in later European Gothic buildings, are characteristic of the Islamic style. The soffits of the arcade surrounding the courtyard of the Great Mosque reveal the complexity of classic Islamic surface design. Interlacing lines, worked in stucco, are as precise as mathematical equations. Balance reflects the order of the universe, and the abstract foliage symbolizes the lush Paradise awaiting the faithful after death. The aniconic (no representations of humans) perspective of Islamic doctrine caused artists to think in new directions, and intricate patterns, often incorporating written texts from the *Qur'an*, became the hallmark of Islamic art.

Malian Muslims living in the city of Mopti assembled in the main mosque (Fig. 6) for a sermon after the noon prayers on Friday. The architectural setting for their communal worship introduces us to an entirely different artistic interpretation of the mosque. West African designers conceived of the building as a flowing sculpture. Clay, the material used for most public

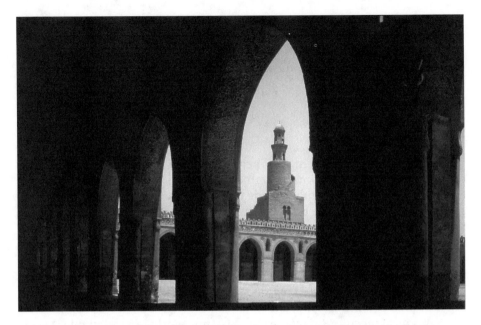

Figure 5 Islamic (Egypt). Great Mosque, Cairo, view into courtyard, minaret in distance; 876–879

and residential African architecture, was smoothed into organic shapes that rise from the terrain like sand-abraded rock formations. Bright lights play off flat, white surfaces bristling with the permanent wooden scaffolding used as ladders for the frequent repairs to clay buildings. The angular, geometric precision of traditional Islamic architecture gives way to a freeform, surrealistic design in which the standard vocabulary of column, arch, and dome is out-of-place.

The degree to which customs that predated Islam survived in medieval Africa depended on the attitude of the local ruler. Many kingdoms and individual communities were professed Muslims, but they often retained animist beliefs and reverence for the ancestral dead. Other kingdoms matured outside the sphere of Islamic influence.

Ife

Ife was the center of a non-Islamic kingdom in medieval Nigeria. It was the city of the *oni*, the divine king who presided over a sophisticated court for which artists created exquisitely naturalistic sculptures in clay and bronze. Many Ife statues are portrait heads of the oni and members of the palace circle.

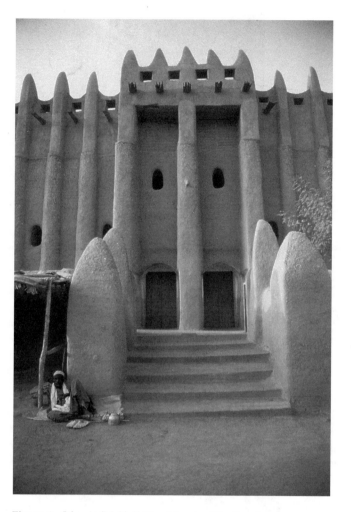

Figure 6 Islamic (Mali). Friday Mosque, Mopti; entrance

An exceptional full-length Ife bronze is the Standing Oni (Fig. 7), dis-
covered in the mid-twentieth century while workers were digging a founda-
tion for a new building. The face is rendered with sensitive idealism, modeled
in soft volumes that swell in natural curves repeating in the corpulent stom-
ach, an indication of physical well-being. The proportion of the head to the
body reveals the full scope of African abstraction that is present even in nat-
uralistic art. It reflects a recurring ideal that emphasizes the head, the seat of
intelligence and personal strength, over the body, the agent of physical
strength. The ratio results in a stocky figure, but the frontal pose and sym-
metric composition recall the dignified presentation of the ancient Egyptian

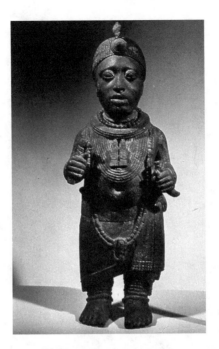

Figure 7 Ife (Nigeria). Standing Oni,
ca. 950–1400; bronze, 18″ H. Museum of
Ife, Nigeria

pharaoh, himself a divine ruler like the oni. Upon the death of an oni, such images were placed in shrines where the collective history of the royal lineage was preserved in visual form. In non-Islamic communities of the medieval and subsequent colonial periods, oral traditions, augmented by visual images, substituted for writing.

Benin

From Ife, the Nigerian kingdom of Benin inherited the bronze casting technique and the concept of a divine ruler, called an *oba*. Benin art was associated with the oba and his court; possessing a work of art indicated high-social status. Visual images glorified the reigning oba and memorialized deceased obas in commemorative statues.

Bronze plaques represent one facet of artistic production in medieval Benin. According to seventeenth century reports by Dutch merchants, they had adorned the exterior of the oba's palace. About nine hundred plaques survive, all rectangular and approximately the same size. Our example (Fig. 8) depicts the oba in a stately costume of coral crown, coral necklaces and small masks secured to his belt. His superior size, central location, and elevated position indicate his importance in the society. Local chiefs, also wearing belt masks, raise

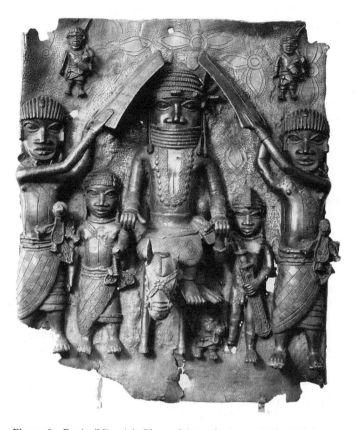

Figure 8 Benin (Nigeria). Oba and Attendants, ca. 1550–1680; bronze, 19 1/2" H. The Metropolitan Museum of Art, New York

their ceremonial swords in allegiance. In this work we must interpret graduated size, from the small, levitating soldiers to the large oba, to mean rank rather than distance, as it does in Western illusionistic art. However, most figures gravitate to the bottom edge of the composition where a groundline is implied.

Benin art is a synthesis of the two medieval traditions we have seen, the naturalistic Ife and the geometric Islamic styles. The proportion of head to body is identical to the Ife oni, but the stocky body forgoes the muscular definition of its predecessor. The decorative pattern of river leaves, interpreted with greater freedom than the previous Islamic architectural reliefs, resembles embroidery on rich fabric. The recessed pattern is a linear foil to the figures cast in high relief.

Benin art is a living tradition, and an oba resides in the capital city today. Many works we will see from the colonial period grew out of older, medieval heritages also.

COLONIAL AFRICA

While the mechanisms of colonialism had been set in place earlier, the colonial period was clearly demarcated by 1885 when, at an international conference in Berlin, delegates from European nations officially divided the continent among the interested European parties. Despite foreign presence, African artists created works that encapsulated the unique sub-Saharan aesthetic. Sculpture from the late nineteenth and early twentieth centuries possesses the rhythmic stylization, formal abstraction, and otherworldly presence associated with classic African art.

West African artists made our first examples of colonial period sculpture. Anonymous Asanti and Yoruba sculptors fashioned small wooden statues depicting an identical subject, an infant. The pair will introduce the range of inventive abstraction in colonial African art.

Asanti

The *akua ba* (Fig. 9) was created by an Asanti carver, a people descended from an influential medieval kingdom that had flourished in modern Mauritania. In the Asanti community, an akua ba was associated with childbirth. According to anthropologists, a pregnant woman carried the figure in her clothing in hopes of giving birth to a beautiful child. Expressively, the statue is a lyrical interpretation of the perfect baby. Its whimsical beauty captures the essence of any mother's dream, a quiet and pudgy, well-behaved and healthy child. An akua ba is recognized by its oversized, discoid head, neck with fat rings and vestigial body with tiny arms extended in expectation. Facial features are clustered in the lower half of the face, balanced against the broad, flat forehead; brows connect with the fine-line nose to create a flower-petal motif.

Yoruba

The *ibeji* figure (Fig. 10), carved by a Yoruba artist, was associated with death rather than birth. It was a vessel for the spirit of a deceased twin child. The mother kept the statue indefinitely, dressing and feeding it like a living person. Without the ibeji the dead twin could torment the parents and lure the surviving twin into death. The mature body is an appropriate receptacle for the enduring spirit, which would not want to remain an infant forever.

Large, heavy-lidded eyes and a full, smiling mouth are features of the Yoruba style; elaborate coiffures mounting in repeated arcs are also typical. The stocky proportions harken back to the Ife and Benin traditions, which had developed earlier in the same region. The eye treatment should recall ancient Nigerian Nok ceramics. In comparison to the moderately abstract Yoruba rendition, the Asanti body appears severely geometric.

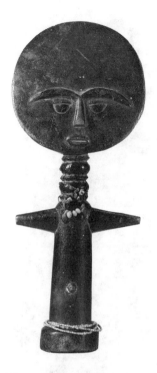

Figure 9 Asanti (Ghana).
Akua ba, late nineteenth and
early twentieth century.
Courtesy of The Art Institute
of Chicago

Dogon

Sculpture created by Dogon artists is as stark as the uncompromising
terrain in which the people live. Dogon villages are small clusters of stone
houses and granaries clinging to the barren cliffs that rise along the Niger
River in Mali.

Something of their harsh existence is reflected in the Seated Couple
(Fig. 11), a prime example of the world-renowned Dogon style. The expres-
sive carving is cubistic with evident cut marks made by an adze. The heavy
tool, an axe with its blade secured at a right angle to the handle, was brought
down on the wood with forceful precision. Although lively voids penetrate
the block, the silhouette preserves the contour of the tree from which it was
hewn. The lean Dogon figures, conceived in clarified segments, have twig-
like limbs with limp pellet hands and feet, and tubular bodies we might de-
scribe as bony but not skeletal.

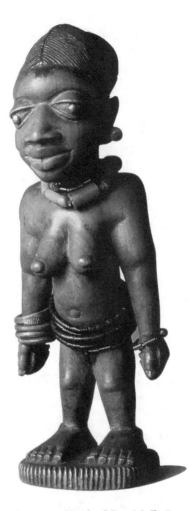

Figure 10 Yoruba (Nigeria). Ibeji,
before 1877; painted wood, metal, coral,
10″ H. Linden Museum, Stuttgart

So similar are the two figures that it is difficult to distinguish the man from the woman. Both faces are passive masks, but he has a beard, while she has a cylindrical lip plug. They share ancestral motifs of conspicuous breasts and protruding navels with radiating scarification patterns.

The statue is said to represent the first parents, the Dogon Adam and Eve. To emphasize the theme, the man places one hand on his wife's breast, as nurturer, and rests his other hand on his genitals. According to the Dogon, the stool is a metaphor for the universe. The seat represents the heavens, the base is the earth, and the center post is a cosmic tree connecting the zones. The

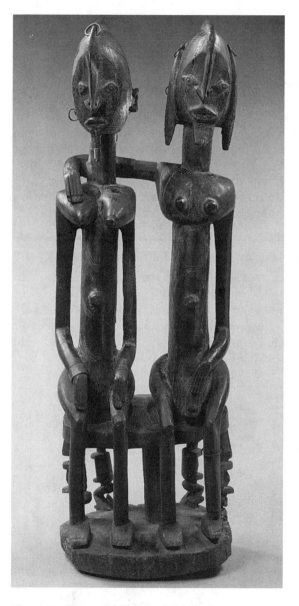

Figure 11 Dogon (Mali). Seated Couple, late nineteenth
and early twentieth century; wood, metal, 28 3/4" H.
The Metropolitan Museum of Art, New York

small, flexed-leg figures represent four pairs of hermaphroditic humans born
to the ancestral couple. Using selective abstraction and a minimalist approach,
the artist communicates the creation story of the Dogon people.

Luba

While Dogon art is visually brutal, the sculpture of certain Luba carvers is serene. It catered to a wealthy nobility whose refined lives required specialized articles such as the neckrest in Figure 12. A neckrest supported the imposing hairdo of a Luba aristocrat while the lord or lady slept.

Elegance is the hallmark of Luba sculpture attributed to the Master of the Cascading Coiffures. Whether the neckrest was the work of an individual or a regional workshop is unknown, but it possesses the defining characteristics of the style. They include a monumental fanned or lobed coiffure and a smooth, polished surface. The artist reveals his design mastery in the play of interlocking limbs, alternations of bent and straight legs that establish a gentle rhythm quite unlike the Dogon couple's ramrod stiff frontality. Anatomical proportions are altered to enhance the compositional flow. The sleek surface of the Luba work exudes a genteel air, while the chopped Dogon surface is aggressively expressive.

Often the surface of an African work reinforces the meaning or purpose of the piece. Fine Luba sculpture in the style we have discussed has a slick, oiled surface that bespeaks a carefully tended object. Old Dogon statues, on the other hand, are heavily encrusted with sacrificial matter because they were used as ceremonial altars. Although many African statues have been "cleaned up" to make them presentable for display in Western museums,

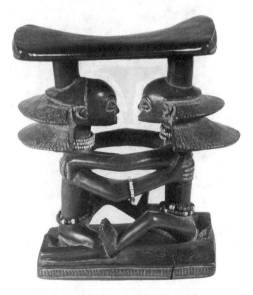

Figure 12 Luba (Zaire). Neckrest, by the Master of the Cascading Coiffures, late nineteenth and early twentieth century; wood, 7 1/2" H.

both surface treatments are appreciated among collectors of African art. Materials, frequently chosen for their rarity, add to the auspiciousness of the works. Wood is a precious resource in the Dogon lands. For imperial funerary sculpture, ancient Egyptians had imported granite from Nubia, and although carving the dense stone was difficult and time consuming, it enhanced the purpose of the work. Both groups of artists respected the integrity of their materials, fashioning images that conformed to the cylindrical tree trunk and cubic stone block, respectively.

Kuba

The helmet mask (Fig. 13) created by a Kuba artist in Zaire has an opulent surface. Wood, metal, fabric, skins, pigment, raffia, beads, and cowrie shells were combined in a mixed–media piece of contrasting colors and textures. The restless surface was stitched, carved, and painted in an adaptation of natural materials to an artificial design that was regulated by tradition.

Performers wore the mask during court ceremonies dramatizing the origin of Kuba kingship. It represents Mukenga (sometimes referred to as Woot), the mythical founder of the royal family. He is a fantastic elephant, recognized by the protruding trunk that arches over a human face. In the manner of the Kushite sphinx, the Kuba mask documents a worldview that sees a symbiotic relation between humans and animals. The belief that people and beasts, as well as women and men (Dogon hermaphrodites), were once

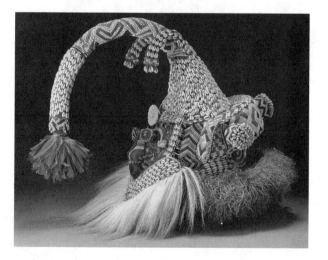

Figure 13 Kuba (Zaire). Helmet mask of mythic royal ancestor, Mukenga, late nineteenth and early twentieth century; mixed media, 27 1/2" H. Courtesy of The Art Institute of Chicago

merged beings appears in several contexts in African art. Additional royal emblems on a Kuba mask can include monkey and leopard skins, the latter an imperial emblem in Benin as well.

Kota

Our final African work was created by the Kota people, who live in small villages in the nearly impenetrable rainforests of Gabon and Cameroon. Ancestor veneration has been a dominant theme in Kota culture. Ancestral bones document lineages, and very old bones have medicinal powers.

Bones were stored in sacred baskets called *reliquaries*, protected from evil by statues such as the reliquary guardian in Figure 14. The reliquary guardian is a radically abstract, mixed-media sculpture carved from wood and wrapped in metal sheets and wire. The head is a collection of precise geometric shapes, with the three-dimensional pyramidal nose and conical eyes laid on a

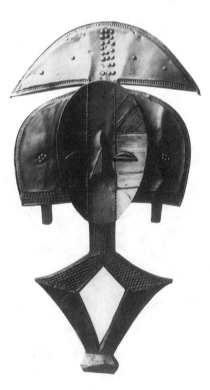

Figure 14 Kota (Gabon). Reliquary
guardian, late nineteenth and early twentieth
century; brass sheeting over wood.
Smithsonian Institution, Washington, D.C.

two-dimensional oval ground. Winglike projections balance the face with a sweeping arch. The pierced lozenge, an exceptionally abstract version of a torso, makes the body of the Asanti akua ba seem robust by comparison.

Although the Kota reliquary guardian may seem simple, the work represents, for our study, the culmination of a tradition that sought the essential, meaningful elements of the subject. In European art of the twentieth century, the intellectual process is called the "search for significant form." With their tradition-inspired "search for significant form" the anonymous Kota artists affected Western art in ways they never could have imagined. In 1906 European painters, including the inventors of cubism, Pablo Picasso and Georges Braque, discovered Kota reliquaries at a Parisian exhibition of "curiosities," as the African works were called. The process of abstraction, which had preoccupied European artists through the nineteenth century, was accelerated by contact with African designs. Kota statues offered Western artists a well-developed alternative to illusionistic art.

2

India

The subcontinent of India is a cultural hearth of Asia. It was the birth-place of Buddhism and Hinduism, two religions with worldviews that helped mold the character of Asian art. Situated on the crossroad between the East and the West, India received and disseminated ideas. India was subject to repeated invasions, yet important ideas retained from each encounter were melded into a unique vision.

Our study is divided into four parts that trace the chronology of Indian visual expressions from the ancient Harappan civilization through Buddhist, Hindu, and finally, Islamic art. That the Indian vision could accommodate these diverse concepts speaks to its ecumenical attitude.

Indian art reflects an awareness of the immense diversity in existence. Vacillating between the minute and the infinite, the particular and the universal, it is tightly structured yet incredibly varied. Parts may be understood, but the total picture seems always beyond human comprehension. Indian art, like the Indian worldview, perceives life to be a multitude of interdependent entities.

An appreciation of life, manifest in abundant flora, fauna and, especially, youthful men and women, is another key idea in Indian art. The love of life is reflected in rhythmic curves that establish a hypnotic movement of turning, interlocking elements, unifying the compositions, joining men to women, people to nature, and sculpture to architecture. Indian art is never self-conscious in its celebration of physical beauty, but alongside an admiration for worldly things exists a passionate regard for the contemplative life, the world of meditation, intellectual pursuits, and spiritual awakening. Existence is a harmony of body, mind, and soul.

Indian art served many functions relating to this worldview. It could instruct people with visual sermons, provide a role model for virtuous behavior or a focus for meditation. Certain Hindu works were created to contact a deity. In these instances, the painting or statue was not considered to be the deity, but the god or goddess could be coaxed into residing temporarily in the image. Being in the presence of images was spiritually beneficial, as was commissioning, making, and donating them.

ANCIENT INDIA

Harappan Civilization

The oldest Indian civilization, the Harappan (2300–1750 B.C.E.; also called the Indus Valley Civilization), is named for an archaeological site near the Ravi River in northwestern India. Excavations at another major Harappan city, Mohenjo-daro, on the banks of the Indus River in modern Pakistan, reveal that among its estimated thirty-five thousand residents were farmers, merchants who traded goods to the Near East, and artisans who built the city with clay bricks. Products by Mohenjo-daro's image-makers shed light on the early Indian worldview.

Harappan seals (Fig. 15), interpreted as merchants' marks used to identify shipments of Indian commodities, represent a sculptural form frequently found at ancient Indian sites and in cities in the Near East. A Harappan seal is an approximately two-inch square piece of soapstone suspended on a cord passed through a raised loop on the back. On the obverse, images were carved below the surface of the stone so that a raised design was produced when the seal was impressed in damp clay.

Subjects on Harappan seals range from animals, such as the naturalistic bull, to enigmatic creatures. Although nothing about Harappan beliefs is

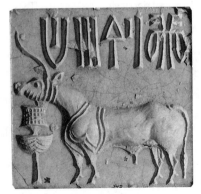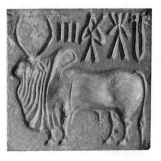

Figure 15 Harappan. Seals, ca. 2300–1750 B.C.E.; plaster impressions of steatite originals, 2″ square

known with certainty because the cryptic writing on the seals remains unde-ciphered, scholars associate the bull with ancient virility cults. The animal's gently swelling form is testament to the artist's keen observation of nature. The abstract rendition of horned humanoids on other seals (not illustrated) imparts a ceremonial, supernatural quality to the objects, leading to the pro-posal that some were amulets. Specialists surmise that these intriguing crea-tures may be ancient forms of the Hindu god, Shiva. Certain elements, including a meditating posture, triple faces, trident-shape atop his head, and prominent phallus, prefigure aspects of the Hindu god.

The small copper statue of a young woman (Fig. 16), also from Mohenjo-daro, was probably associated with ancient fertility cults. Numerous clay stat-ues ascribed to an Earth Mother cult have been found, but this example is an unusual Harappan item for its material and open silhouette. The shortage of metal sculpture from Harappan sites is probably due to the desirability of the material, and undoubtedly many examples were melted down in subsequent eras to make coinage or weapons.

The young woman's posture anticipates the distinctive hip-shot pose of women in later Indian art. Nudity, accentuated by copious jewels, documents the antiquity of the Indian attitude toward the body. The young woman, self-assured and nearly confrontational, shows no trace of uneasiness. Even at this early date in Indian art, nudity is a natural and desirable condition. Eventually it will become an expression of confidence and well-being. The ethnic char-acter of the Dravidians, the indigenous Indians of the Harappan civilization, is evident also.

Vedic Period

By 1750 B.C.E. the Harappan territories had been infiltrated by foreign nomads from the Iranian plateau. The appearance of the invaders, who called themselves *Aryans* (nobles), undermined the already deteriorating Indian civ-ilization. The Aryans drove the Dravidians south and subjugated those who remained in the old Harappan heartland. To date, no art has been ascribed to the Aryans, but they cultivated an elaborate cosmology that profoundly af-fected subsequent Indian thought. The era of Aryan domination is named the Vedic period (1750–500 B.C.E.) after their sacred scriptures, the *Vedas*.

Aryans envisioned a cosmic Law (*dharma*) that governed the supernat-ural world, nature, and social behavior. The Law was perfect order and the interrelatedness of all components. *Caste*, the social division of the population into four ranked, hereditary categories, was an aspect of the Law.

Violating any part of the Law, willfully or unknowingly, had dire con-sequences because punishment was doled out in a future life. Similarly, obe-dience was rewarded in another life. The concept of action and consequence is called *karma*. An individual experienced karma as the soul moved in and out of countless lives. Death always commenced a new existence, never lib-

eration. The soul was indestructible, and in a lifetime it temporarily assumed the form of any animate being, from an insect to a god. The concept of endless rebirths in different forms is called *samsara*.

The goal of life was the cessation of rebirth, achieving a blissful rest that came to be called *nirvana* among Buddhists and *moksha* among Hindus. Liberation was attained by uniting the individual soul with the eternal world soul, Brahman. The individual was extinguished, absorbed into the great permanence of Brahman. Methods to achieve liberation included meditation, self-mortification, and denial of the physical world. Only the most disciplined individual could aspire to eternal rest. Everyone else was doomed to move through the ceaseless rounds of samsara, obeying the Law and gradually inch-

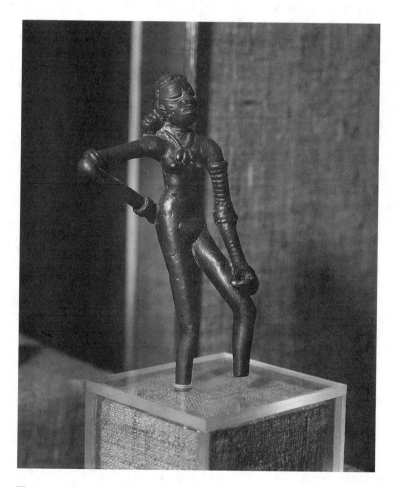

Figure 16 Harappan. Young woman, ca. 2300–1750 B.C.E.; bronze, 4 1/4″ H. National Museum of India, New Delhi

ing closer to desirable extinction. Then the Buddha was born to give a new perspective on the Law and a new way to cope with samsara.

BUDDHIST ART

The historical Buddha (556–483 B.C.E.) was an Aryan prince born near the Indian border in Nepal. He is known by the names Gautama, Siddhartha, and the title Shakyamuni, which means "wise man of the Shakya clan." At age twenty-nine he abandoned his family and the pampered life in the palace. His mission was to discover why people seemed doomed to lives of suffering and death. After six years of wandering and fasting his quest was rewarded. Sitting under a tree, he meditated until coming to understand that the cause of suffering was attachment to things of the world. Henceforth, he was known as the Buddha, the "Enlightened One."

The Buddha shared his method for achieving enlightenment, encapsulated in a code for virtuous behavior (Eightfold Path) by preaching in the Ganges River Valley. Many people were attracted to his teachings, and he acquired a considerable following. At the age of eighty the Buddha Shakyamuni laid down and died a peaceful death; he attained freedom. His disciples formed a monastic order of men and women, devoting their lives to attaining enlightenment. They did not proselytize, yet the new attitude about life and the Law took hold in India.

Early Buddhist Art

Before the third century B.C.E. Buddhists created no works of art, apparently requiring only solitude for their meditations. As the Buddhist community burgeoned, images were formulated to clarify doctrine and mark sacred locations. Under the sponsorship of Emperor Ashoka (reigned 269 to 232 B.C.E.) Buddhism thrived, and sacred sites numbered into the tens of thousands under his patronage.

Buddhists outside the monastic order could gain merit by visiting sacred sites. The focal point of a pilgrimage site was a large, solid earthen mound that covered a relic associated with Shakyamuni or a renowned monk. The mound (stupa) is surrounded by a fence (vedika), a device used in India since remote antiquity to demarcate a sacred site. Four gateways face the cardinal directions.

The Great Stupa at Sanchi (Fig. 17) is a superb example of this classic form of Buddhist architecture. First built during Ashoka's reign, the Great Stupa was doubled in size about two hundred years later. At that time the old wooden gates and vedika were replaced with the current stone versions. The solid brick and rubble hemispherical mound, originally faced with white stuccoed stone, rises from a drum-shaped base. On the summit a square terrace (harmika) encircles a pole with three discs. Symbolically, the mound is the World Mountain, Mount Meru, and the pole is the World Axis. The discs rep-

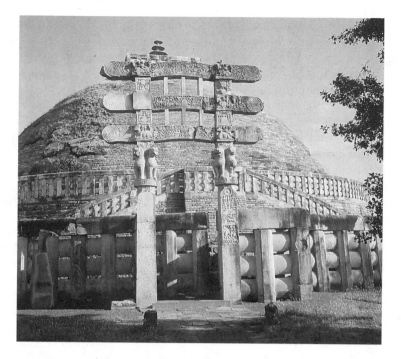

Figure 17 Buddhist. Great Stupa, Sanchi, first century B.C.E. to first century
current era; stupa 55′ H, 130′ D; vedika 10′7″ H.

resent umbrellas, an emblem of royalty in India. The number three is mean-
ingful in Buddhist art, signifying the three Jewels of Buddhism (the Buddha,
the Law, and the monastic community).

Between the vedika and the mound is a continuous walkway (*ambula-
tory*). To use the building, a Buddhist would follow the ambulatory, walking
around the stupa in an act of meditation. A double ramp provides access to
the second ambulatory on the drum. The building is closed-form architec-
ture, oriented to the exterior. It possesses no interior space, no "functional"
space in the traditional Western sense.

Before pilgrims began their meditations they were instructed by images
carved on the entrance gates. Many Buddhist sites have extensive carvings on
the vedika also. The crisp carvings on the East Gate are encyclopedias of
Buddhist symbols. The number three is repeated in the horizontal crossbars,
the vertical connecting posts, and the trident atop the right support. Circular
shapes, representing the Wheel of Law, abound. With a flowing rhythm they
harmonize the carvings with the mound itself. Umbrellas and elephants, the
vehicles of royalty, remind us of the Buddha's high caste. Additional symbols
denoting the Buddha include lions (he was the "lion of the Shakya clan"),
miniature stupas, and trees symbolizing his place of enlightenment.

Noteworthy on the East Gate of the Great Stupa is the figure that forms the bracket connecting the lower horizontal beam with the vertical post on the right. She is a female type called a *yakshi*, a robust nude representing the abundance of nature. Yakshis are nature spirits that survived from an ancient Indian heritage predating Buddhism. Her type can be traced to the Harappan copper statue. While many yakshis are specific nature spirits, they represent the more general concept of abundance. In Indian lore, a yakshi can cause a tree to bloom with the kick of her heel. Her body zigzags in the *triple-flex pose* characteristic of Indian figures. The Sanchi yakshi is dynamically conceived with exceptional interior carving. She is a precursor to the voluptuous women of later Buddhist and Hindu sculpture.

Monastic complexes were also sites for early Buddhist architecture. Dormitories and assembly halls such as the one at Karli (Fig. 18) were carved into the mountains. The Buddhist assembly hall, called a *chaitya hall* (also the name for the pointed-top, horseshoe-shaped arches), was excavated in the side of a cliff. Instead of joining materials to enclose spaces, that is, "constructing" a building, Karli craftsmen worked in a subtractive method, removing tons of stone to introduce voids into the solid mountain. Starting at the ceiling, they chipped their way down to the floor and back through the mountain in a method more akin to sculpture than architecture.

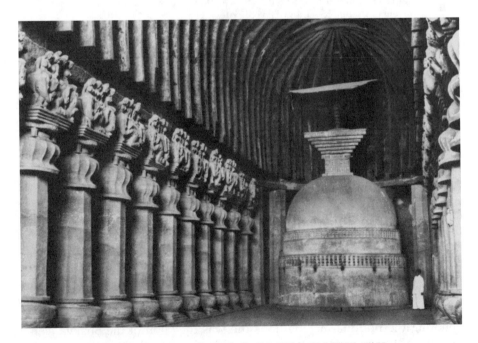

Figure 18 Buddhist. Karli, interior chaitya hall, 120; 124' L, 46 1/2' W, 45' H.

A chaitya hall has a rectangular plan that ends in a semicircular space where the focal point of the interior, the stupa, is found. The interior is divided into a central nave and two side aisles created by the colonnade; the ambulatory allows passage along the walls and behind the stupa. Once again, an individual "uses" the building by walking around the stupa. The columns are surmounted by amorous couples and gigantic lotus blossoms, symbolic of purity.

Since the columns support nothing, we realize that the designers were replicating another form of architecture in stone. This is particularly evident along the ceiling where nonfunctional rafters are introduced. The chaitya hall is a stunning imitation of an ordinary building made of wood and thatch. The implication may be that permanence is really illusion.

A large relief carving of a loving couple (Fig. 19), located on the otherwise badly damaged facade of the Karli chaitya hall, introduces us to the mature Indian aesthetic of the human body. The woman is full to bursting with the abundance of life, her tapered waist and ankles emphasizing ample hips and breasts. Both figures are adorned with fine fabrics, jewels, and huge earspools. Sensuous energy flows through the swaying scarves, intertwining arms, and curvaceous hips. In their smiling expressions we sense that they take great pleasure in physical opulence. Indian artists translated a generous spirit into generousness of the flesh, rendering the reward of good karma in a manner all viewers could comprehend.

What is missing at Sanchi and Karli is a depiction of the Buddha himself. Because there were no images of the Buddha in the first centuries, the early phase of Buddhist art is often called *aniconic*. Since no prohibitions forbad his depiction, we can assume that it was considered illogical to show the Buddha in a physical form because his greatest accomplishment had been the attainment of liberation. Many early carvings depict events from his life and his former lives (jataka tales), but his presence in the narratives is merely implied.

Figural Buddhist Sculpture

We turn now to the most famous images from Indian art, the actual depictions of the Buddha. Precisely when the figural Buddha was conceived is unknown, but it was firmly in place by the first century of the current era.

The Buddha may be represented in a standing or sitting pose, but he is always presented in the frontal position. When standing, the weight of the body is evenly distributed through the legs. The Indian Buddha is stationary; he is always in a state of perfect rest. When seated, he often assumes the meditative *lotus position*, with his feet placed soles up on the thighs.

The position of the hands is especially important in Indian art. Symbolic hand gestures (*mudras*) signal an activity or indicate a state of spiritual consciousness. In Indian art, hand gestures, rather than facial expressions, communicate information. In Figure 22 the Buddha performs the *teaching mudra*,

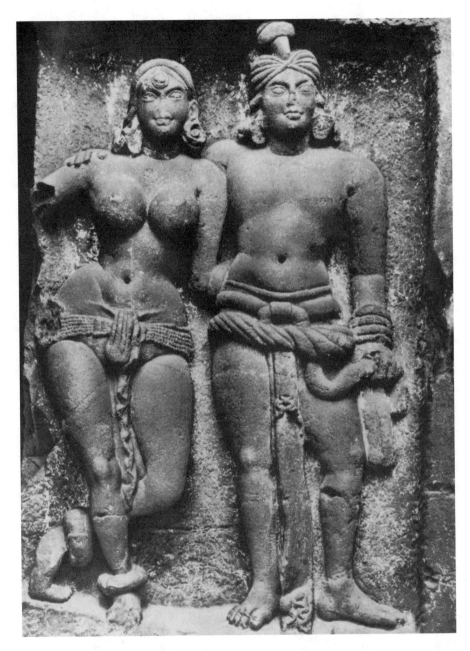

Figure 19 Buddhist. Loving couple, Karli, early second century; stone

joining the thumb and index finger to form the Wheel of Law, which he turns with the other hand. Other gestures include the *reassurance mudra*, performed with one hand raised to shoulder level (Fig. 20), palm out, and the *meditating mudra*, recognized by both hands resting on the thighs, palms up, and finger tips touching. Positioning the left palm outward with fingers pointing downward is the *gift-bestowing mudra*.

Clothing, accessories, and marks on the body are also important in identifying the Buddha. His simple monastic garment may bare one shoulder or cover the entire torso. An Indian Buddha never wears jewelry, because he has renounced the illusion of the material world. Therefore, long ear lobes are a sign of the Buddha because he has removed the large earspools of a prince. Additional signs include a dot (*urna*) on the forehead and a protuberance (*ushnisha*) on top of the head, represented with a knot of hair. Both the urna and ushnisha indicate superior wisdom, as does the halo, the burst of Buddha light.

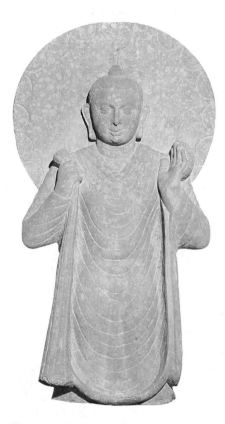

Figure 20 Buddhist (Mathuran).
Standing Buddha, second century; stone

Other characters resembling the Buddha are nearly-buddhas called *bodhisattvas*, enlightened beings who delay their own liberation and remain on earth to help people achieve enlightenment. The Standing Bodhisattva (Fig. 21), possibly the Buddha-of-the-Future, Maitreya, would have carried his personal attribute, a flask with the elixir of life, in one hand and raised his other hand, often imprinted with the Wheel of Law, in a gesture of reassurance to the audience. Frequently, the Buddha is shown in the same standing pose, but the earspools and princely garment, which we saw at Karli, show that the bodhisattva is still within the earthly realm.

While Buddhist symbolism remained consistent through the centuries, the manner in which the figure was presented developed rapidly through three stylistic phases. The Mathuran and Gandharan styles appeared simultaneously in the first century of the current era. They flourished during the Kushan period (50–320), merging in the fourth century in the classic Indian style, the Gupta. The three Buddhist statues we have examined for their iconography represent these styles.

Artists in Mathura, a capital city of the Kushan empire, fashioned the Standing Buddha (Fig. 20) in the brusque, comparatively abstract Mathuran style. The Buddha's engaging stare and frozen smile contribute to the commanding attitude. Although the authoritarian demeanor was short-lived in Indian art, the Mathuran treatment of the body persisted in subsequent periods. Muscles are generalized into flat smooth planes, particularly evident in the broad chest. The powerful body, filled with a breath that expands it like a balloon, is marked with drapery folds that are thinner and more linear than the weighty Gandharan counterparts. Mathuran sculpture is considered to be the indigenous Indian style, evident when we compare Figure 20 to the Karli loving couple; the anatomical definitions and smiling expressions are similar.

Some seven hundred fifty miles north of Mathura, artists in Gandhara, a northern Kushan province in modern Afghanistan and Pakistan, explored another stylistic alternative for the Buddha image. The Gandharan style was inspired by Western art brought from the Roman Empire by way of an international commercial thoroughfare, the *Silk Route*.

Features of the Gandharan style are evident in the Standing Bodhisattva (Fig. 21). The pronounced musculature, wavy hair, and heavy drapery, all Roman imports, are united with the Indian mood of contentment and introspection. Physical beauty reflects spiritual beauty, which is the theme of Buddhist art. The quality of carving, with its deep undercutting, imparts a mysterious aura to the Gandharan sculpture. Although the debt to Roman art is obvious, this bodhisattva would have been out-of-place in ancient Rome.

The two hundred year reign of the Gupta kings (319–500) is considered the golden age of Indian art. Artists fused the best of the Mathuran and Gandharan styles to create the unique Gupta synthesis of physical and spiritual beauty.

The statue entitled Sermon in the Deer Park (Fig. 22) exemplifies the fully

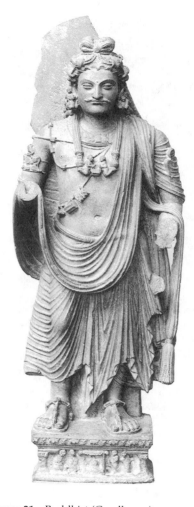

Figure 21 Buddhist (Gandharan).
Bodhisattva, second century; stone.
Courtesy, Museum of Fine Arts, Boston

developed Gupta style. The Indian artist envisioned a mysterious being with a vaguely human presence. Gupta Buddhas are renowned for their other-worldly composure and inner peace. The downcast, lotus-petal eyelids and boneless body convey the inner peace that comes from enlightenment. His smiling expression is tender yet enigmatic. Serenity is a feature that distinguishes the Gupta style from its predecessors.

Another Gupta characteristic is the refined carving. The delicate, transparent drapery flows in smooth transitions, clinging like water-soaked fabric to his chest and arms. The edge of the monastic garment is arranged in a

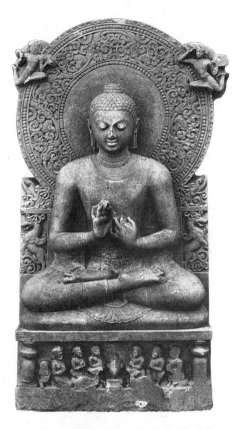

Figure 22 Buddhist (Gupta). Seated Buddha
(Sermon in the Deer Park), ca. 475; sandstone,
5′3″ H. Museum of Archaeology, Sarnath

neat pleated fan resembling the Wheel of Law in the relief carving. The wheel
motif unifies the composition, from the circular halo, through the mudra, to
the garment and finally the narrative carving at the base. The subject of the
relief carving beneath the throne is the Buddha's first sermon after experi-
encing enlightenment. Five hermits, soon to be his disciples, join a woman
and her child in venerating the foreshortened Wheel of Law in the center.

 As the Gupta Buddha was simplified, the setting became more elabo-
rate. From the stark Gandharan discs, to the scalloped-edge Mathuran haloes,
we arrive at a foliated burst of buddha-wisdom in which concentric rings of
lotus petals, vines, and jewels reflect a rich universe. Pairs of wisdom-bearers
augment the halo, and winged lions flank the sides of the seat of enlighten-
ment. In the center, the Buddha represents quiet repose in a busy world.

 An anomaly of Gupta art is that its sponsors, the Gupta kings, were not

Buddhists but Hindus. Gradually, Buddhism was transformed into a religion of charms and incantations, squeezed into a smaller and smaller territory until it ceased to be a motivating force in Indian art. The aesthetics refined in the golden age of Indian Buddhist art lived in Hindu art for the next thousand years.

HINDU ART

Hinduism is the world's largest polytheist religion, both in the number of people embracing its precepts and the number of deities it perceives. The tally of gods and goddesses is potentially infinite, because each is an aspect of the ultimate reality, Brahman. Several deities were brought by the Aryans. Others such as Vishnu grew out of the Vedic tradition but were altered so significantly that an Aryan never would have recognized his original god. The oldest, Shiva and the Great Goddess, can be traced to the virility and fertility cults of the Harappan civilization. Some gods such as the sun god, Surya, are manifestations of natural phenomena, but most are embodiments of abstract concepts. To compound the multiplicity, the major deities exist in more than one form. Shiva, for example, has one thousand eight names. He can combine with other deities to create, for example, a split image with one half Shiva and the other half Vishnu.

The Hindu world is anything but chaotic, however. Order exists in the immense diversity. From among the hosts, a person selects one or more deities for personal veneration, a practice called *bhakti*.

Images of Hindu Deities

In the Hindu pantheon one female and three male deities are supreme. The Great Goddess is the major female deity. Brahma the Creator, Vishnu the Preserver, and Shiva the Destroyer form a trinity. We will select a few manifestations of Vishnu, Shiva, and the Great Goddess to explore the ways in which Indian artists structured images to communicate complex ideas. Using bronze, stone, and paint, artists materialized a world populated by beings of nearly impenetrable intricacy.

Vishnu is the focus of intense devotion and the subject of innumerable works of art. As the agent of the Law, Vishnu maintains order in the universe. The copper statue of Vishnu (Fig. 23), costumed as a king in jewels and regal crown, shows him in a stately pose befitting the defender of the Law. Regardless of the activity in which he is engaged, Vishnu is always composed.

The two animal heads represent Vishnu's third and fourth *avatars* (incarnations). When evil threatened to disrupt cosmic harmony, he assumed these different forms. On the right is the Boar avatar. In this episode, he became a gigantic boar, forty miles wide and forty thousand feet tall, to rescue the earth from an evil serpent king. For his next avatar, Vishnu was incarnated as a lion (left) to destroy a disrespectful king who had desecrated his emblem.

Meaningful items (*attributes*) help identify the gods and goddesses in Hindu art. Among Vishnu's attributes are three weapons, a conch shell, a disc, and a mace. In our example, the shell and disc take a human form, with the personification of the disc standing on the left and the shell on the right. Each deity also has an animal vehicle to transport it. Vishnu's vehicle, not represented in this statue, is the sunbird. Every male deity has a female comple-

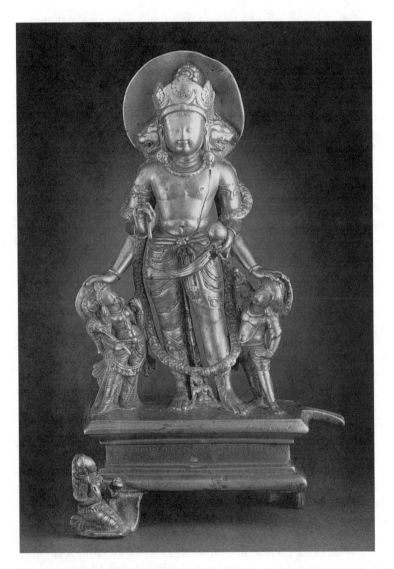

Figure 23 Hindu. Vishnu, ca. 850; brass with silver and copper inlay, 18 1/4" H. Los Angeles County Museum of Art

ment represented as his wife. Sri Lakshmi, goddess of wealth and good fortune, is Vishnu's consort. His constant, adoring companion appears between his legs in this statue. Outside the space of the majestic deity, the devout follower, also the patron of the statue, gazes with admiration.

For his eighth avatar Vishnu assumed human form, incarnated as the princely cow-herder and charioteer, Krishna. The adventures of young Krishna, narrated in the monumental Hindu text the *Bhagavad Gita,* inspired Indian painters from the seventeenth century onward. The episodic format of manuscript painting suited the Krishna epic, from charming anecdotes of his childhood to supernatural triumphs of his manhood. In an eighteenth century manuscript painting (Fig. 24) Krishna subdues Kaliya, evil serpent-demon and ruler of a watery kingdom, who had terrorized the village herders. Kaliya is annihilated by Krishna's dance, but the serpent's wives escape his wrath to join villagers and animals in a chorus of praise. The tale is interpreted as a symbolic triumph over local animist deities and the supremacy of the Krishna cult over ancient Indian beliefs.

Krishna's romantic exploits constitute a major body of Hindu painting. Women found the fickle, blue-skinned Krishna irresistible. He was the trickster, stealing their clothes when they swam, and the seducer, taunting and teasing them with his provocative ways. Among all the women, he truly loved Radha, who was utterly devoted to him. In his absence, Radha suffered miserably but when he arrived, she would melt into joyous submission. The popular story of Radha and Krishna is a metaphor for the relation between the loyal Hindu and the god. For those who have chosen Krishna as their personal deity, as have the villagers and serpent-queens in the Kaliya narrative, he is the heart's sole desire, and spiritual union with him is an ecstatic experience.

Shiva is more difficult to embrace because he is the unpredictable god. He is the lord of the beasts, the god of the hermit mendicant, and the embodiment of virility. Appropriately, his vehicle is the bull, Nandi, and his jewels include snakes. Shiva wears a tiger skin and carries a trident. With his wife, Parvati, he lives in the vile cremation grounds or in his mountain abode in the Himalayas.

Shiva is the Destroyer of illusion. As Lord of the Dance (Fig. 25) he tramples ignorance, personified by the prone dwarf beneath his foot. With a flaming cadence he annihilates a universe deceived by the fallacy of permanence. On the right, he holds the flame of destruction. On the left, he keeps the relentless rhythm of destruction and creation with an hourglass drum. In the other meaningful pair of gestures he offers comfort to the audience; with one hand he performs the reassurance mudra and immediately below it, points downward where refuge may be found beneath his upraised leg. In the madness there is hope. Great strength exists in his fluid motions.

Many versions of the Lord of the Dance can be seen in museums around the world. The image is famous because it encapsulates the Indian world-

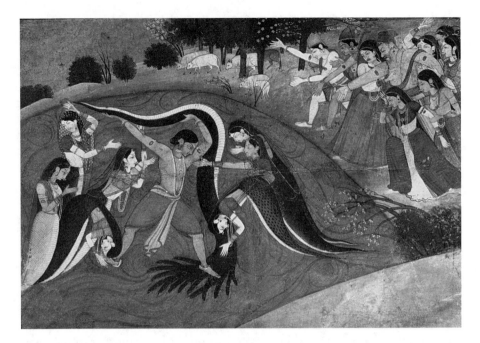

Figure 24 Hindu (Rajput). *Krishna Overcoming the Naga Demon, Kaliya,* second half eighteenth century; color on paper, 7 3/8" H. × 10 3/8" W. The Metropolitan Museum of Art, New York

view in a beautiful composition of circles and lilting lines. Metal statues created between 1000 and 1100, during the Chola period, capture the state of dynamic balance most eloquently.

Our final Hindu deity is a manifestation of the Great Goddess. As the embodiment of the earth's creative energy, she possesses the power to conceive and sustain life, so she is often represented as a yakshi-type, nurturing woman. As repository of the dead, however, the earth also consumes life. In this horrifying manifestation, the Great Goddess is Chamunda, destroyer of evil (Fig. 26) or Kali, the "Black One." No illusion disguises the unappealing reality of death, captured in the grimacing face and the deflated breasts hanging on her skeletal torso. Often her ornaments include a garland of skulls and jewels of snakes and body parts; in this example, a scorpion, emblematic of death, crawls up her torso. Eight-armed Chamunda displays the weapons of the male gods; Shiva's trident and Vishnu's disc-topped mace are intact. Additional attributes of the wrathful manifestation of the Great Goddess can include a cup of blood, a ritual dagger, a severed head, and beneath her throne, a recumbent male, ordinarily Shiva.

When reviewing the Hindu images, it becomes apparent that certain el-

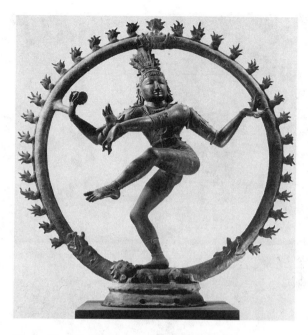

Figure 25 Hindu (Chola). Shiva Nataraja, eleventh century; copper, 43 7/8" H × 40" W. The Cleveland Museum of Art

ements continue the Buddhist aesthetic. Figures are fluid and boneless in the Gupta style. Centered in the composition, they are presented in a frontal position and possess meaningful mudras. However, Hindu art is more interactive and animated than Buddhist. To express the deity's extraordinary nature, Hindu artists took considerable liberties with the figure. Multiple heads and limbs, as well as combinations of animal and human elements, were devices for rendering its special qualities. Hindu artists erased the lines demarcating animate and inanimate, animal and human, supernatural and mundane.

Hindu statues were focuses for meditation and temporary receptacles for the deities who could, by means of an image, come into people's presence. Images were created for private devotions at home and for temples. More appropriately, we should say that the temples were created to house statues in a suitably grand and mysterious setting.

The Hindu Temple

In southern India, at the site of Mamallapuram, stand four unfinished temples (Fig. 27) that were carved from a granite protuberance. The build-

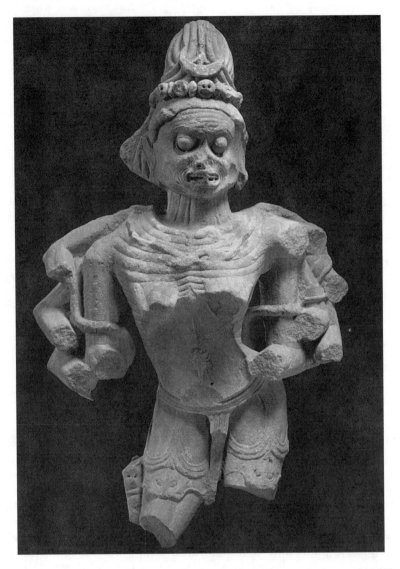

Figure 26 Hindu. Chamunda, tenth and eleventh century; sandstone, 44 1/2"
H. The Metropolitan Museum of Art, New York

ings are called *raths*, meaning "chariots," because they resemble the wooden
wagons on which statues were, and still are, transported in public proces-
sions.

In comparison to later mature temples, those at Mamallapuram are ex-
ceptionally small. Possibly they were functional shrines, but the abnormal size

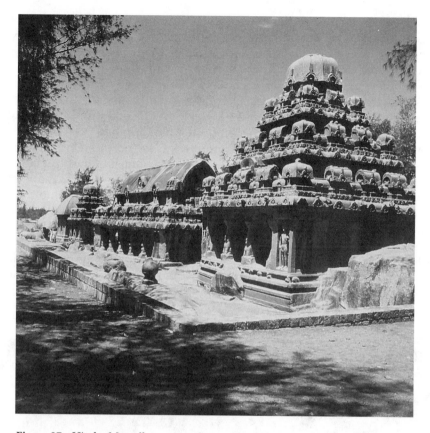

Figure 27 Hindu. Mamallapuram raths, ca. 630–670; granite, Durga shrine
(distance) 12' H, Dharmaraja rath (foreground) 36' H.

and the linear arrangement of progressively more elaborate styles have led
specialists to interpret the Mamallapuram site as an "architecture school."
The shrines may have been three-dimensional models that were studied by
architects from other Indian cities. They document the evolution of the Hindu
temple from an unpretentious hut to a complicated tower.

 The simplicity of the Durga shrine in the distance identifies it as the old-
est form at Mamallapuram. It replicates ancient wooden plank and thatch-
roof forest shrines. The evenly spaced pilasters create the illusion of wooden
poles supporting a massive thatched roof. Although the blank walls are un-
usual for a Hindu temple, the Durga shrine possesses several features that are
common in all Hindu temples. They include the building elevated on a plat-
form carved with animals, as though bearing the deity in procession, the union
of a square plan and circular roof, and, finally, doorkeeper statues flanking
the entrance.

The Dharmaraja rath in the foreground comes very close to the mature Hindu temple style of southern India. The surface is more sculptural, with deeper niches for the relief carvings. A major change is evident in the roof, where a three-story stepped pyramid rises to a mushroom-shaped capstone. The roof is a miniature tower, each tier a miniature city with vaulted buildings and thatched-roof shrines. Decorative chaitya arches, the horseshoe-shaped architectural element we saw at Karli, ornament the roof and capstone.

By the eleventh century, the Hindu temple form had been perfected. A temple to Shiva at Khajuraho (Fig. 28) represents the northern Indian version. The tower of Kandariya Mahadeva rises in diminishing but multiplying units from a telescoping platform. In an illusion of rippling waves, the vertical movement of the tower is continued by the horizontal bands of molding on the base. The cream-colored sandstone was originally stuccoed white to simulate Shiva's snow-capped Himalayan abode.

For all its complexity, a Hindu temple possesses few necessary spaces. Its heart is the small, dark sanctuary where the principal statue dwells. The location of this "womb chamber" (*garbhagriha*) is indicated by the tallest tower. An assembly hall (*mandapa*) and an entrance porch complete a temple plan.

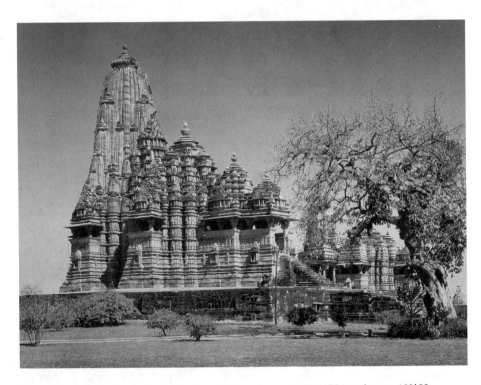

Figure 28 Hindu. Kandariya Mahadeva, Khajuraho, ca. 1025–1050; sandstone, 102' H.

Kandariya Mahadeva is exceptional for its unification of architectural spaces. Similarly, the sculpture is integrated into the building, so that the division between the two media is indistinguishable. Renderings of all the deities, the wonders of nature, and the familiar loving couple (Fig. 29) abound. With this sensuous work we grasp fully the enthusiasm with which Indian art embraced life. The couple's curvaceous weave is in marked contrast to the hard-edged isolation of the couples we encountered in Africa (Fig.11).

ISLAMIC INDIA

Hindu and Islamic art spring from oppositional worldviews. Because one envisions the divine to be infinitely divisible, while the other was founded on the belief in an indivisible supreme being; we can expect the visual expressions to be similarly divergent.

Islam was imported in several hesitant military campaigns beginning in the eighth century. Major portions of India were not secured until the late twelfth century. Fighting between Muslim and Hindu factions raged until one Muslim family, the Mughal, unified the subcontinent. Hindu princes were reduced to vassals, and the majority of Hindu temples in northern India were systematically dismantled. Despite the destruction, Indian art flourished under the patronage of Islamic emperors during the first hundred years of the Mughal dynasty (1526–1857).

The Taj Mahal (Fig. 30), a mausoleum commissioned by Mughal emperor Shah Jahan (reigned 1627–1658) in memory of his beloved wife, Mumtza Mahal, epitomizes the restrained opulence of Islamic architecture. It represents an unexpected foil to the fleshy exuberance of Hindu temples. The domed mausoleum is raised on a rectangular platform with four minarets anchoring the corners. The pointed arches, recalling those we saw in Islamic Africa, move the design upward to the swelling dome. The masonry core is covered with polished white marble inlaid with gold, silver, jade, diamonds, and other precious stones.

Around the entrance, intricate stone inlays of Qur'anic verse and floral arabesques provide clues to the deeper meaning of the Taj Mahal. Designed to replicate Paradise, it represents Mumtaz Mahal's reward for her steadfast faith against the Christian infidels. She will be with Allah in Heaven. The magnificent setting is as meaningful as the building because it emulates the celestial gardens. Symmetry dictates the placement of every element in the walled garden, from the intersecting reflecting pools to the symbolic fruit trees of eternal life. In its reserved elegance, the Taj Mahal testifies to the abiding love of the man for his wife, and the woman for her God.

Painting flourished under the Mughal potentates also. Its eclectic blend of Persian, European, and Indian styles attests to the cultural tolerance in Islamic India when religion was not involved.

To experience a Mughal painting gallery we would not walk through rooms but page through books. The preferred format was the *manuscript il-*

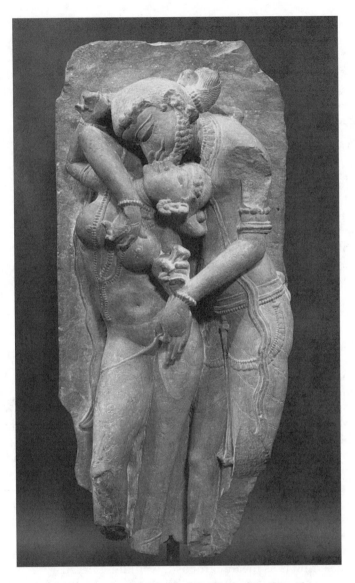

Figure 29 Hindu. Loving Couple, from Khajuraho, eleventh
century; sandstone, 29" H. The Cleveland Museum of Art

lumination, a painting in a bound book. Many subjects were illustrated, from
the fantastic adventures of Alexander the Great to biographies of the Mughal
emperors.

Shah Jahan's grandfather, Akbar (reigned 1556–1605) established the
first Mughal painting workshops at his court. Producing a painting required

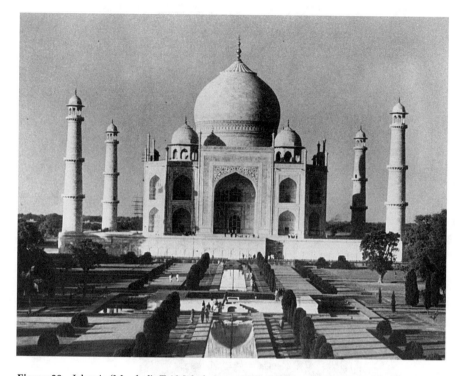

Figure 30 Islamic (Mughal). Taj Mahal, Agra, 1630–1648; marble, inlaid stones, gems; 186′ square, base and dome 250′ H.

the expertise of many specialists, who were supervised by the court librarian. After the handmade paper had been prepared, the master artist laid out the composition. Specialists painted the portraits by layering tones, rather than by blending wet paint on the palette. The task of applying color to the clothing and background was assigned to lesser artists.

An episode from Akbar's life, the arrival of two Christian priests at his Islamic court, is documented in Figure 31. The painting is a curious blend of Persian and European elements. Persian features include the flat patterns and the upward surface movement. The minutely rendered details produce a bewildering surface, however, the two-dimensional abstraction that ordinarily characterizes Persian painting is offset by European artistic influence, brought by the Portuguese in 1498. Modeling, realistic portraiture, and vignettes of everyday life are characteristics of Western art incorporated into the Mughal painting.

Hindu painting assimilated many Mughal elements, but, as Figure 24 shows, it remained more abstract. Hindu manuscript painting is called *Rajput* (prince) painting, because it was sponsored by Hindu warrior-kings who con-

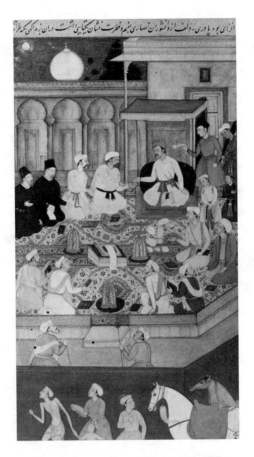

Figure 31 Islamic (Mughal). *Akbar Receiving Jesuit Priests*, from an *Akbarnama*, by Nar Singh, ca. 1605; opaque watecolor, gold, ink on paper. Chester Beatty Library, Dublin

tinued to rule small, independent kingdoms. Rajput painters flatten the space, integrating figures and background into a decorative pattern. Bodies of unlikely proportions are molded into unnatural positions. They retain the sensuous appeal of the earliest Indian art.

3

The Indian Surround

Commerce and colonization brought about the amicable Indianization of lands adjacent to the subcontinent. People were receptive to Buddhist and Hindu ideas because they found the Indian concepts of social order and moral responsibility beneficial. Indian imports were often reconstituted in fantastic theological and visual aberrations, and in some cultures, Buddhism and Hinduism were indistinguishable. Contributing to the unique mutations were frequent realignments in the politically volatile areas and the persistent beliefs in local, pre-Indian nature spirits. Each culture that came in contact with India absorbed its traditions and adapted them to regional needs.

Our attentions will focus on Tibet, a bridge between India and China, and Southeast Asia, a geographic unit consisting of mainland Indochina and the Indonesian islands. In Southeast Asia, Buddhism was established by the seventh century, and works of art were first created in the following century. The images followed models that monks and merchants had brought from India, possibly as early as the fifth century. In Tibet, Buddhism was in place by the tenth century. While the monastic community nurtured Tibetan Buddhist art, most Southeast Asian art was initiated in palaces. In Southeast Asia, religion was an administrative tool, a means by which the king proclaimed his right to rule. Tibetan art was spiritually motivated. Southeast Asian art was often political.

TIBET

Buddhism underwent its greatest transformation along India's Himalayan border in Tibet, where ancient shamanic practices affected the theology and visual arts. *Shamanism* is the belief that gifted individuals possess

powers to interact with spirits. In the bleak, brutal Tibetan environment, demons roamed a psychic world alien to the ordered Indian mental universe. The attitude produced fearful implements of gold and human bones for magical rituals and fantastic costumes for religious dramas. Tibetan Buddhism is an esoteric religion, its mysteries impenetrable to those outside the monastic communities.

A *tanka* (Fig. 32) is a magical painting filled with charms and visual incantations that serve as loci for energy and focuses for meditations that gather energy. Something of that unseen power resonates through the painting, the patterns repeating like utterances in a chant. The blunt style, with its shrill palette of intense green, red, and yellow, concentrates psychic forces.

Figure 32 Tibet. Vajrapani Tanka, probably eighteenth century; opaque watercolor on cloth. American Museum of Natural History, New York

The tanka has the linear clarity of a map because that is exactly what it is. The abstract designs are cosmic diagrams; the recurring square shapes, called *mandalas*, are diagrams of the universe. The four equidistant T-shaped projections are entrances to the cosmic spaces. The circle of Mount Meru, the World Mountain, is inscribed in the center of every square earth. Enshrined goddesses and buddhas complete the points of meditation on the metaphysical journey through a tanka. Tibetan monks fashioned intricate tankas with opaque paint on cloth. Another medium was dry colored sand, the product of the monks' patient skill always destroyed soon after its creation.

JAVA

Sometime around the year 800 the stone monument, Borobudur (Fig. 33), was built atop a low hill on the island of Java. It is perhaps the most remarkable Buddhist monument in the world, a testament to the magnitude of imperial vision, the erudition of island scholars and the tenacity of Javanese artists. Reminiscent of the Tibetan tanka, Borobudur is an architectural mandala, a huge stone replica of the earth and the World Mountain. Javanese Buddhists literally walked the mystic path that Tibetans followed mentally in the painted picture.

The nine levels of Borobudur represent three cosmic zones, changing

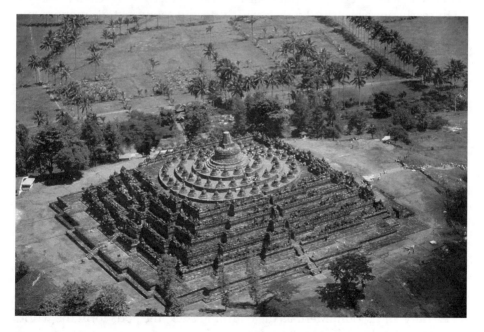

Figure 33 Java. Great Stupa, Borobudur, ca. 800; 408' each side, 105' H.

from five square basal terraces to three circular levels and a top circular plat-
form. Ten miles of stone carvings encrust the surface. The bottom levels of
Borobudur represent the mundane zone of human existence. In a practice
seen elsewhere in Buddhist art, the carvings at this level were deliberately
hidden behind stone slabs, the implication perhaps that the participant was
aware of invisible dangers on the path to enlightenment. The celestial zone
is represented in the four middle terraces, where miles of relief carvings il-
lustrate the life of the Buddha and his unrelenting quest for enlightenment
through his former lives. The Buddha's journey was an inspiration to the per-
son journeying through the cosmos of Borobudur. Over four hundred free-
standing Buddha statues punctuate the path on these levels. On the top three
circular levels, seventy-two statues of the Buddha sit in hollow, bell-shaped
stupas. An empty stupa, representing the world of the formless, crowns the
summit of Borobudur. The sculptural program takes the pilgrim from ordi-
nary subjects, the world of people and objects, to the sphere of pure idea, the
attainment of enlightenment.

CAMBODIA

Traces of inspiration from Borobudur are evident in the monuments
built for the Khmer god-kings of Cambodia. King Jayavarman II (died 850)
had lived on Java before founding the five hundred year long Khmer dynasty
in the early ninth century. By the early thirteenth century, stone monuments
were self-serving statements of imperial vanity.

Jayavarman VII (reigned 1181–1219), a dedicated patron of Cambodian
architecture, sponsored the rebuilding of the royal capital, Angkor. His own
walled temple-city in Angkor, called Angkor Thom, was a worthy addition
to the existing extravagant projects that had aggrandized the god-kings for
centuries. In the center of Angkor Thom stands the Bayon (Fig. 34), the finest
in a long line of Cambodian temple-mountains. Like the mandala, it is square
in plan, with a central tower, Mount Meru, and four lower corner towers. The
cosmic ocean is actualized by a surrounding moat and four canals repre-
senting the World Rivers.

The giant face-towers rising from the tiered roofs are combined portraits
of the king and the royal bodhisattva, Lokeshvara, the Lord of the Worlds.
From the earliest times, Khmer kings claimed descent from a divinity, either
a Hindu god or Lokeshvara. The broad, serene smile and closed eyes are
uniquely Cambodian. Huge statues of kneeling gods line both sides of the
north and south roads leading to the Bayon. They pull on a giant stone ser-
pent wrapped around the central Bayon tower. The stone assemblage recounts
a Hindu creation myth, the Churning of the Milk Ocean. Using the serpent
of eternity and Mount Meru as the churning stick, the gods form the world
out of watery chaos, like butter from milk.

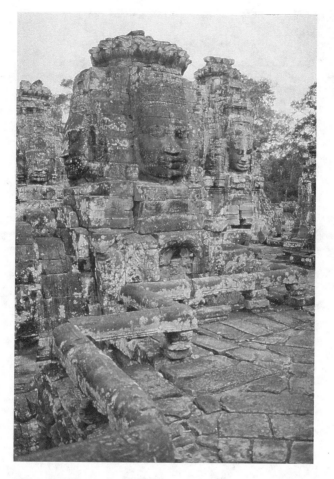

Figure 34 Cambodia. The Bayon, Angkor Thom, late twelfth and early thirteenth century; 140′ H.

THAILAND

The art of Thailand carried the imprint of classical Indian aesthetics throughout its history, from the earliest fifth century Buddhist works created by indigenous Mon (Dvaravati) people, through the tenth century Cambodian Khmer invasions and subsequent occupation, to the emergence of the Thai style in the thirteenth century.

Our example of Thai sculpture (Fig. 35) shows the Buddha performing the *calling-the-earth-to-witness mudra*. This pose illustrates a specific moment in the Buddha's life when a troop of demons and luscious ladies, representing the forces of earthly desires, attempted to divert his thoughts

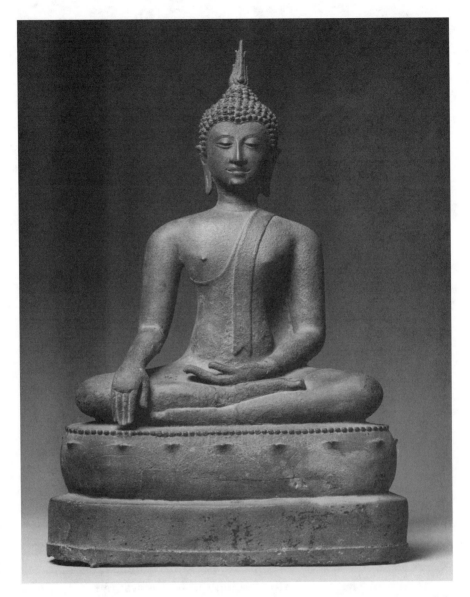

Figure 35 Thailand. Seated Buddha, late fifteenth and sixteenth century; bronze, 19 1/2″ H. The Metropolitan Museum of Art, New York

while he sat under the tree seeking enlightenment. After repulsing their temptations, the Buddha summoned all creation to witness his triumph. This is the subject depicted most often in countries where the older form of Buddhism, called *Hinayana* (Theravada) Buddhism, is practiced. Hinayana

Buddhists recognize only the historical Buddha, Shakyamuni, not the bod-hisattvas and multiple celestial buddhas of the more popular *Mahayana* Buddhist doctrines.

Of all national Buddhist styles, Thai is perhaps the most distinctive. Its elegant stylization, with elongated limbs, smooth surfaces, and the flame-shaped ushnisha are unmistakable. Literal translations of poetic descriptions of the Buddha, such as eyelids like lotus petals and arms like an elephant's trunk, inspired the more unusual visual passages. Nevertheless, the Thai style captured the tranquility of an enlightened being. It is the logical culmination of Indian Gupta abstraction.

4

China

If multiplicity shaped the character of Indian and Southeast Asian art, then duality was the compelling force in Chinese art. The paradigm of Chinese duality is yin and yang. *Yin* is the female principle; it is earth. Yin is flexible, cold, low, wet, dark, and passive. Its male complement, *yang*, is sky. Yang is rigid, hot, high, dry, and active. Yin and yang are interactive. Neither is superior. Life's dynamic energy, as well as its harmony, arises from the symbiotic mix of these two forces.

That life was activated by mutually supportive opposites, polarities that were complementary rather than antagonistic, was a possibility explored by Chinese philosophers. Two philosophies, Confucianism and Daoism, provide the underpinnings of Chinese thought, art, and society.

Confucius (551–479 B.C.E.) was the spokesman for the ethical code that bears his name. *Confucianism* is not a religion, but a set of moral standards governing proper conduct. Confucianism upholds the importance of decorum. Among the rules and expectations regulating social and familial relations, respect for one's parents (*filial piety*) is particularly important. Art often addressed the topic of filial piety. Specialized items such as vessels used in ancestral rites ensured that filial piety continued beyond the grave.

The complement to Confucian order is the freedom of *Daoism*, a philosophy traditionally credited to the enigmatic Chinese sage, Lao Zi (604–531 B.C.E.). Daoism envisions a dynamic, life-sustaining energy flowing through the universe. Artists could open themselves to the vitality of the Dao if they were flexible and yielding. Art swirls with abstract lines that simulate the energy of the Dao. In the Daoist worldview, the vital force of life moves through a great void. Works of art were often designed around meaningful negative

spaces that provided the structure and the center of interest in the composition. In China artists discovered that empty areas can be very powerful, and that a pause in visual silence can be more arresting than a commotion of shapes.

The natural world was the ultimate source of inspiration for Chinese artists. Vegetables and insects were rendered with the same detail accorded emperors and gods. Depending on the moment in history and the purpose of the object, styles fluctuated between abstraction and naturalism. Works of art were magical objects, emblems of authority, signs of superior cultural refinement, mechanisms for the preservation of information, and vehicles for self-expression. Succinctly stated by the world's first art historian, Chang Yen-Yuan (847), art helped human relations and explored the mysteries of the universe. Art, he wrote, completes culture.

The imperial families lent their names to most epochs in Chinese history. The earliest dynasties of the third millennium B.C.E. are still considered legendary, but archaeological evidence has confirmed the existence of the *Shang* dynasty and the kings who ruled China from around 1766 to 1045 B.C.E. Works of art and written documents add to our understanding of the ensuing dynasties of ancient China. The house of *Zhou* (1045–256 B.C.E.) wrestled power from the Shang, and they in turn were overthrown by the *Qin* (221–206 B.C.E.). The subsequent *Han* dynasty (202 B.C.E.–220) is considered a golden age of Chinese culture, both summarizing and amplifying the achievements of the ancient world.

Buddhism made its appearance during the politically muddled period following the collapse of the Han dynasty. Once order had been restored, an artistic renaissance commenced in the *Tang* dynasty (618–906), only to be arrested by another era of political realignment.

The fluorescence of Chinese painting was centered in the *Song* dynasty (960–1279) courts. China's most devastating invasion, the onslaught of the Mongols, terminated the Song and instituted the foreign *Yuan* dynasty (1279–1368). The invaders were rebuffed, and the *Ming* dynasty (1368–1644) and the *Qing* dynasty (1644–1912) carried China into the twentieth century. Throughout the political cycles, Chinese art expressed the abiding principles of order and energy.

The material in this chapter is organized in two parts. The first highlights sculptural achievements, and the second is a chronological overview of Chinese painting. Although references will be made to the dynasties, our attention will be directed to artistic attitudes, materials, and subjects.

THREE-DIMENSIONAL MEDIA

Chinese artists excelled in fashioning small scale, precious objects. Monumental stone statues were created, but to appreciate the technical mastery and artistic inventiveness for which Chinese art is renowned, we select works created in clay, bronze, jade, and wood.

Ceramics

Clay provided Chinese artists with a versatile creative outlet. They took advantage of the pliable substance to fashion vessels, first in unglazed earthenware and later in shiny glazed porcelain. By the eighteenth century of the current era, "china," as Europeans called it, was a major Chinese export. In ancient China, ceramic statues were included among the grave goods. Clay lent itself to abstract designs in which proportion and placement were principal concerns. It was also an avenue for realism.

Ceramists were among China's first artists. Their products are associated with one of the oldest cultures in the world, the neolithic Yangshao culture (5000–2000 B.C.E.), which is named for a region in China. Excavations at the archaeological site, Banpo, show that the Yangshao people lived within fortified villages in semisubterranean pithouses.

Among the grave goods from Yangshao sites are distinctive mortuary vessels (Fig. 36) with bulbous bodies and narrow, raised rims. Yangshao ceramics were handbuilt using long ropes of clay spiraled into the desired shape, a technique called *coiling*. Rubbing with a stone erased the ridges and produced the surface sheen. Already we notice the duality in Chinese design, with the division into large void and energy-filled compartment. Pairing the swirling lines with representation of oval cowrie shells, a form of ancient Chinese currency, anticipates later combinations of real and fanciful elements.

Four thousand years separate the Yangshao mortuary vessel from the jar (Fig. 37) created by Yuan dynasty potters. By the fourteenth century shiny

Figure 36 Neolithic (Yangshao 5000–2000 B.C.E.). Burial urn, ca. 2200 B.C.E.; painted earthenware, 14 1/8" H × 7 7/8" D. The Seattle Art Museum

Figure 37 Yuan dynasty (1279–1368). Jar, ca. 1375; porcelain with underglaze blue decoration, 15 3/4" H. The Cleveland Museum of Art

glazed porcelain, painted in cobalt blue on a creamy white ground, had replaced the burnished Yangshao earthenware, painted in shades of brown and red. Glazed porcelain is a translucent ceramic made of fine, soft clay fired at a high temperature. In a process called *underglaze painting*, new in the Yuan period, cobalt blue was painted on an unfired porcelain surface. The thick glaze was applied before the object was fired. The jar was constructed by pressing clay into section molds; patterns carved on the outer mold left raised designs on the exterior of the vessel.

Typical motifs on Yuan blue-and-white ware include concentric bands of peony tendrils and chrysanthemum scrolls. Foreign ornaments, notably the large *cloud collar* in the center band, remind us that the emperors during the Yuan dynasty were Mongols, descended from the notorious Genghis Khan (1162–1227). Technology had changed considerably, yet the shape and disposition of patterns on the Yuan jar bear an uncanny resemblance to the neolithic ancestor. Chinese artists invigorated ancient forms with new motifs and processes, preserving their visual heritage in the most culturally debilitating atmospheres.

The world's most ambitious undertaking in clay was engineered by the first emperor of China, Qin Shih Huang Di (259–210 B.C.E.). His obsession with controlling the world extended beyond the grave in the most spectacular archaeological find in Chinese history, the emperor's burial complex. While his grass-covered mound remains undisturbed, the surrounding subterranean pits have been excavated. Thousands of life-size statues representing members of the emperor's army have been recovered. No doubt the talents of the nation were enlisted for the project, with pottery workshops across northern China geared up for production.

Each soldier and horse (Fig. 38) is a freestanding, fired clay statue originally painted in vivid colors. Every face is a unique portrait. Coiled and molded techniques were used in the process. The heads were created in molds with the realistic details worked by hand in a wet clay coating. Weighing in at five hundred pounds when fired, the horse is an almost unimaginable feat of ceramic technology. If we included labor consumption on our inventory of features of ancient Chinese art, this clay assemblage would top the list.

For all his unseemly activities such as burning all the live Confucian scholars he could find, Qin Shih Huang Di's clay army represents a humanitarian leap over his predecessors' habit of taking sacrificed soldiers and horses into the imperial graves. Aristocrats soon adopted the practice of including clay replicas of people, animals, and objects in their own tombs. Although never as ambitious in scale as the Qin originals, later ceramic mortuary art reproduced almost every facet of life in ancient China.

Bronze

The feature distinguishing neolithic art from subsequent dynastic art in China is the conspicuous use of bronze. Possessing bronze was a sign of wealth and the badge of authority. Bronze was difficult to mine, smelt, and cast, requiring a labor force that only a king could muster. Many abandoned ancient cities, notably the Shang capital of Anyang, have tombs with abundant bronze grave goods.

In ancient China bronze was cast in two categories of objects, weapons and ritual vessels used in ancestral sacrifices. It was especially important for the king to maintain contact with the imperial ancestors because they were his source of power. Aristocrats soon learned to perform ancestral sacrifices

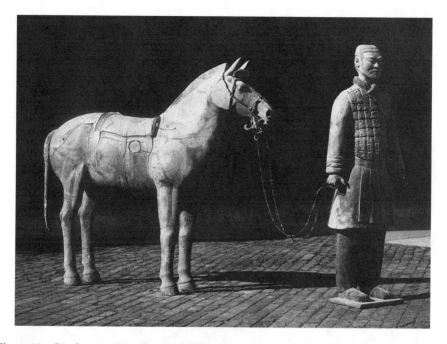

Figure 38 Qin dynasty (221–206 B.C.E.). Warrior and horse from tomb of Qin Shih Huang Di; painted clay, 5′ 10 1/2″ H. Shaanxi Province

in the spirit of filial piety. Ancient Chinese bronze ritual vessels are classified into two groups, those used for sacrifices of wine and those for meat and grain. They were storage, pouring, cooking and serving utensils.

The wine mixing vessel (Fig. 39), named a *yu*, is identified by its bail handle. Our example was cast during the Shang dynasty, a period renowned for its visual innovations. The earliest Shang ventures in bronze reveal technical expertise and metamorphosing human and animal elements. Imaginative associations lent themselves to intriguing pairs such as the tiger, a beneficent emblem of the earth, and the man who stands on the animal's paws to embrace it. An array of typical bronze ornamental motifs, many with symbolic associations that are conjectured at this time, is found on the Shang yu. The surface is covered in C-scrolls that often coalesce into fanciful animal shapes, especially the primitive dragon seen on the lower edge near the tiger's tail. The visual and thematic ambiguities in ancient Chinese design result from the proliferation of disembodied body parts and the absence of blank space (*horror vacui*). The squared spirals (*thunder pattern*) which fill the voids with rhythmic movement remained in the Chinese decorative vocabulary for thousands of years, and we can find it delineated clearly along the rim of the Yuan jar.

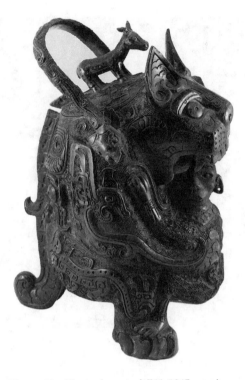

Figure 39 Shang dynasty (1766–1045 B.C.E.).
Yu; bronze. Musee Cernuschi, Paris

Chinese artists were adept at forming bronze into fluid shapes that look more like painted images than cast statues. One example is the mountain-shaped incense burner (Fig. 40), a unique invention of the Han dynasty. It is a functional object and an illustration of an idea stemming from mystical Daoism, often referred to as *popular* or *religious Daoism* to differentiate it from philosophical Daoism outlined in the beginning of this chapter. Among the more engaging aspects of popular Daoism, accounting for its wide appeal, was the promise of immortality through the consumption of magic potions.

The imaginative world of popular Daoism was populated with fanciful creatures and immortal beings whose courts were located on ever-receding mountains enveloped in clouds. The Han incense burner represents an abode of the Immortals, a magic mountain rising from the sea. The linear energy of the old thunder pattern has been recast in gold and silver inlaid swirls. Immortals materialize in the cliffs, and sea monsters peek from waves that crest in solid foam on the shore. Smoke emitted from holes in the vessel once mingled with the metallic clouds. The illusive boundaries between substances reflect the Chinese penchant for transformations.

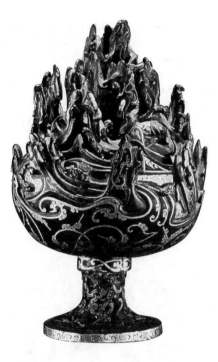

Figure 40 Han dynasty (202 B.C.E.–220).
Incense burner from tomb of Prince Liu
Sheng (died 113 B.C.E.); bronze with gold
and silver inlay, 10 1/4″ H; 7 lb 8 oz.
Museum of Anhui Province

Devotion to the Daoist Immortals was overshadowed temporarily by
the arrival of a new "supernatural," the Buddha. Buddhism entered China
along the Silk Route during the Han period, but it was so foreign that cen-
turies passed before it was assimilated into Chinese culture. How, for exam-
ple, could a revered father return in another life as a goat? When the goal of
a Daoist was immortality, why would extinction be appealing? Many Indian
customs, essential to Buddhist art, were abhorrent in China. Pierced ears,
bared torsos, and shaven heads were considered barbaric.

It seems logical that the first people in China to embrace Buddhism were
foreigners to the Chinese. The Toba Wei, a group of Turkish ancestry, built a
Buddhist kingdom in northern China during a period of political upheaval,
the *Northern and Southern* dynasties (265–581). The Toba Wei excavated monas-
tic complexes in the mountains near the Great Wall of China, but their colos-
sal stone Buddhas were ill-proportioned misinterpretations of Indian models.

Northern Wei artists were more comfortable in the old Chinese medium,
bronze, and later statues show a growing sophistication. Although the

Standing Buddha (Fig. 41) incorporates the lotus pedestal and circular halo with lotus tendrils, the image is definitely not Indian. The mudras, a raised reassurance gesture and a downward gift-bestowing gesture, are too emphatic. Both derive from Indian Gupta sculpture, but the close placement suggests a yin and yang pair. Agitated drapery conceals the body. Fabric conveys energy in Chinese art, and rarely is the body an expressive element. Recalling the inlaid gold swirls on the Han incense burner, the full length pointed halo is a flame of lines invigorating the space.

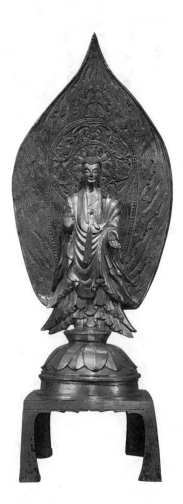

Figure 41 Northern Wei (386–535). Standing Buddha (or Maitreya), 535; gilded bronze, 4′ 6″ H with pedestal and halo. The University Museum, University of Pennsylvania

Wood

Five hundred years after the demise of the Toba Wei, another group of foreigners, the Liao, a nomadic people of Tartar descent, built a small kingdom in northern China. In this second period of political chaos, Buddhist images took on a grace and physical splendor that eclipsed the beauty of their Indian prototypes.

The magnificent painted wooden statue of the bodhisattva of compassion, Guanyin (Fig. 42) is attributed to Liao artists. The cascading drapery and knotted streamers possess a startlingly tactile quality, and the stiff peaks of Northern Wei garments become limp bundles of sensuous fabric. The earlier verticality is softened by a languid ease. Guanyin is dignified yet gracious, while the bronze Standing Buddha is hieratic and remote. Irregularity characterizes the Guanyin composition, from its rocky pedestal to the posi-

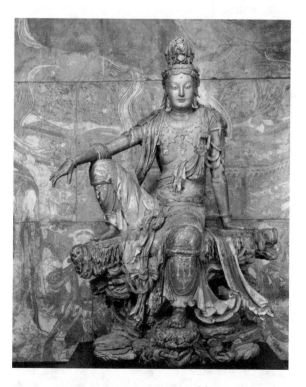

Figure 42 Liao (or Northern Song dynasty; 960–1127). The Water and Moon Guanyin; gilded, painted wood, 95″ × 65″. The Nelson-Atkins Museum of Art, Kansas City, Missouri

tion of the limbs. In contrast, the Standing Buddha is balanced and predictable. As we will discover soon, both Buddhist statues were three-dimensional renditions of contemporary Chinese painting.

Jade

Chinese artists excelled in difficult, time-consuming techniques. Because jade was an exceptionally trying material to carve, it was prized for its indestructibility. Jade was also appreciated for its streaked color, described by ancient Chinese writers as a vital spirit surging through the hard stone. To Confucius, jade symbolized the highest moral order.

The phenomenal skill of an anonymous Zhou dynasty carver is evident in the delicately pierced jade object called a *bi* (Fig. 43), a flat disc with a hole in the center. Innumerable examples have been recovered from ancient tombs dating to the neolithic period. With its companion, a prismatic tube (*zong*), they are believed to represent heaven and earth, respectively. For this inventive example of an ordinarily simple shape, the artist constructed a trio of dragons with flourishes of curling Zhou hooks. In the asymmetric grouping, two dragons hunch along the perimeter while one stretches in the center. The

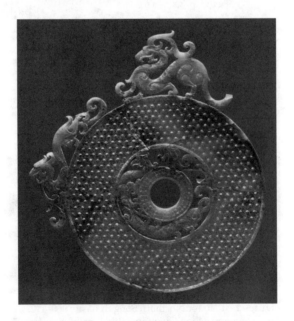

Figure 43 Zhou dynasty (1045–256 B.C.E.). Bi, ca. 475–221 B.C.E.; jade, 6 1/2″ D. The Nelson-Atkins Museum of Art, Kansas City, Missouri

bi seems to breathe with its expanding and contracting shapes. The tiny bosses that make up the *grain pattern* identify this item as a gentleman's bi.

PAINTING

Along with poetry and calligraphy, painting was one of the Three Perfections in Chinese culture. Paintings could communicate information, but above all, an acquaintance with painting indicated superior cultural refinement. Although painters were not always held in highest regard, their works were avidly collected. Chinese painting is one of the few art forms in our study created expressly to appeal to the artistic temperament, the fourth function for art outlined in the Introduction.

Materials and Methods

Before discussing the chronology of Chinese painting, we must consider the materials and methods. Four basic formats were available to the painter. The vertical format, the *hanging scroll*, was ordinarily displayed on a wall, for the enjoyment of a large audience. The horizontal *handscroll*, by comparison, was designed for an intimate audience, usually of one. The oval or pleated *fan* was another format uniquely suited to the leisured life of aristocratic connoisseurs. *Album leaves* were mounted in picture books with fans and scraps of old handscrolls.

The supports for Chinese painting were silk and paper. Since the textures of fine silk and rough paper were integral aspects of the viewing experience, a painter never concealed the support in the way oil paint can cover a canvas. Classic Chinese painting lacks strong color. Because it is worked primarily in shades of gray, it is called *monochrome painting*, even when slight touches of color are included. Monochrome painting is ink painting. Soot and glue were compressed into a solid *inkstick*, which was abraded on an inkstone. The particles were mixed with water. Fresh inks and colors were created for each painting session. To create pigments for richly colored paintings, ground mineral crystals were mixed with water and glue.

Brushes were specially designed for different tasks. Wet and dry brushes, referring to the amount of ink the bristles could hold, were available. A typical brush had a core of stiff bristles encircled by an air pocket surrounded by soft animal hair. Unusual brushes were the size of brooms. What was most important was that the instrument was appropriate to the task. Line quality and tonal range were controlled by the pressure on the brush, the angle of the brush on the support, the density of the ink, and the absorbency of the support. Brushwork was the key element in evaluating the quality of an ink painting. It defined form, carried energy, and revealed the artist's personality. Brushwork interpreted the subject and provided an avenue for self-expression.

Early Painting, Through the Tang Dynasty

To begin our chronological study of Chinese painting we should acknowledge its origins in the neolithic Yangshao culture. The frayed bamboo reed used to create the fluid X-marks on the funerary vessel anticipates the brush in subsequent Chinese painting. Clay would always offer Chinese painters an attractive surface, but it was superseded by silk, the painting support of choice.

The oldest intact Chinese painting on silk is a T-shaped funerary item called a *fei-i* (Fig. 44), which translates "fly-away garment." In 1971 it was discovered on the coffin of a Han aristocrat, Lady Dai, who died around 168 B.C.E. The banner-shaped fei-i foreshadows the hanging scroll so popular in later Chinese art. It was painted with brush and opaque mineral colors in earth tones of red and tan. Flat paint fills firm black outlines, but several individual passages are rendered with amazing realism. Textural variety is a feature of early Chinese painting, evident in the grain pattern on the circular bi and the scaly dragons threaded through its center. Symmetry prevails in this surface-oriented work, but each motif in the numerous pairs is slightly different from its mate.

The purpose of the fei-i was to assist Lady Dai's soul in its flight to the immortal ancestors, therefore, it is replete with symbols that map the Daoist cosmos. In the vertical section, two horizontal lines anchor earthly scenes. Above the bi, a scene of filial piety includes old Lady Dai, bent over her cane, and several respectful attendants, most likely her children. Some distance below the bi is a funeral sacrifice with several bronze ritual vessels. Beyond this ordinary world, the space is filled with Daoist emblems. Most are famous in Chinese culture, and the following short list can help explain many enigmatic images in Chinese art. The important emblems are animals associated with the cardinal directions. Beginning at the top of the vertical section, two phoenixes indicate the south. Dragons of the east frame Lady Dai, and beneath the filial group is the tiger of the west. Two turtles and a snake near the funeral vessels are emblematic of the north.

Because painters in ancient China were considered to be common laborers, it is unlikely that we will ever know the name of the individual who painted Lady Dai's fei-i . An appreciation for artistic genius and individual personality dawned in the Northern and Southern Dynasties period. We would not find these connoisseurs among the Toba Wei buddha-makers in the north, but in the refined southern courts, where individuals devoted time to evaluating artistic quality. Analyzing art was an avocation among the southern nobility. In the closing years of the fifth century of the current era, six points, which have come to be called the *Principles of Chinese Painting*, were outlined.

The first principle says that paintings must have vital energy. The artist must capture the essence of the subject. The spirit animating the image is

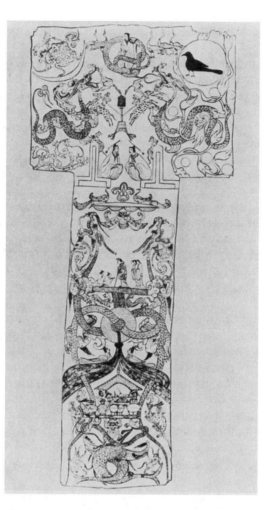

Figure 44 Han dynasty (202 B.C.E.–220). Fei-i from
tomb of Lady Dai, ca. 168 B.C.E.; painted silk banner,
80 3/4″ L. People's Republic of China

more important than its exterior appearance. The second principle states that
vital energy is conveyed through the brushstroke. The strength of the brush-
work, the visible record of energy, also reveals the painter's personality.
According to the third principle, the painting must be faithful to the ap-
pearance of the subject. Capricious distortions would be discourteous to the
subject, and, in the same vein, the fourth principle expects that the colors are
true to the subject. The fifth principle addresses proper composition; arrange-

ments must support the theme, and placement should be both dynamic and meaningful.

The sixth principle is very Confucian because it says that the experiences of the past are transmitted into the present by copying the work of the masters. While the notion of copying another artist's work, line for line, may imply a lack of inventiveness from a Western perspective, it is an admirable artistic expression in Chinese and many other Non-Western cultures. Artists in other communities may be inspired by the past, but the Chinese artist is infused with it. An individual develops respect for the past by reliving the strokes of the masters. Only then can he add to the past with his personal inventions.

From the southern courts, where these attitudes were fostered, came the first important Chinese painter, Gu Kaizhi (ca. 344–406). Since no authenticated original paintings survive, his work is known through old copies such as the *Admonitions of the Instructress to the Ladies of the Court* handscroll. A detail (Fig. 45) shows the virtuous Lady Feng protecting the emperor from a raging bear. The purpose of the scroll was to teach young women proper behavior.

Gu Kaizhi's reputation rests partly on his tight, wiry brushstrokes. They impart dignity, where appropriate, to the most willowy characters. Little movement is conveyed through the figures, but Lady Feng's fluttering ribbons reflect her vital energy, her spirit strength. The Northern Wei sculptors had cast the curling drapery on the bronze Standing Buddha in imitation of these ink swirls. Lady Feng's placement with the armed guards exemplifies the meaningful composition mandated in the fifth principle of Chinese painting. Absent in this painting, and in the Han fei-i, is a setting or a framing device. Each component is spatially isolated on a flat ground.

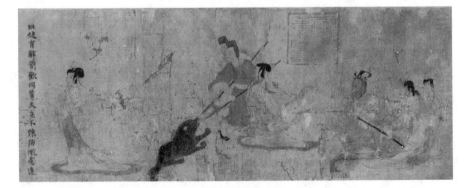

Figure 45 Southern dynasties (265–581). *Admonitions of the Instructress to the Ladies of the Court*, detail, Lady Feng and the Bear, copy after original, by Gu Kaizhi (ca. 344–406); handscroll; ink, slight color on silk, 9 3/4" H × 11' 6" L. British Museum, London

Under the patronage of the Tang emperors (618–906), painting expanded spatially and thematically. Prevailing taste favored realism. Portraits of people and animals, everyday activities among aristocrats and farmers, landscapes and buddhas were subjects we could find in a Tang painter's portfolio. Great events, both heroic and tragic, inspired Tang artists.

A copy after an original Tang dynasty horizontal hanging scroll, *Ming Huang's Journey to Shu* (Fig. 46), presents an episode from the life of that famous but controversial Tang emperor. An avid patron of poetry, music, and painting, Ming Huang (reigned 712–756) also had a special yearning for robust horses and women. Because the army resented his obsession with the courtesan Yan Guifei, it rebelled in 755, driving the emperor, his sweetheart, and court loyalists out of the capital and south to the province of Shu. On the way, Yang Guifei was captured and strangled. The tale of passion and ruin inspired painters and poets for centuries.

The Tang artist divided the narrative into three sections. It begins with the arrival in the valley on the right, pauses with a respite in the center, and concludes with the departure on the left. The procession has the flair of a pageant rather than the desperation of flight and pursuit. It is presented in the colorful *decorative style* (also called the *blue-and-green style*) favored in the Tang

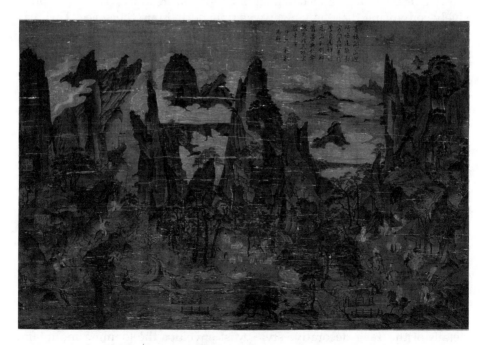

Figure 46 Tang dynasty (618–906). *Ming Huang's Journey to Shu,* Song copy after Tang original ca. 800; horizontal hanging scroll; ink, color on silk, 21 3/4" H. National Palace Museum, Taipei

court. In the decorative style, panoramic scenery overwhelms the figures while sharp details draw our eye to the surface. Overlap establishes an illusion of depth, but the landscape lacks atmosphere. Edges are defined by black ink lines and filled in with flat, opaque colors touched with gold. The jagged mountains and metallic clouds share qualities with the Han incense burner.

Monochrome Ink Painting, Song Through Qing

Chinese painting matured in the Song dynasty courts and in the Buddhist monasteries in the surrounding countryside. The Song army routed the invaders who had toppled their Tang predecessors, but they were forced to flee their capital city of Kaifeng when a new group of insurgents drove the Song court south of the Yangzi River to the new capital at Hangzhou. Therefore, an important distinction is made between the first phase, the Northern Song (960–1127) and the subsequent Southern Song (1127–1279). Although still lifes and genre scenes were painted during the Northern Song period, landscape painting was the supreme expression.

Northern Song. Northern Song landscape painting is called the *monumental style*. The justly famous hanging scroll entitled *Traveling Among Mountains and Streams* (Fig. 47) communicates the majesty of the monumental style. The painter, Fan Kuan (active 990–1030), created a vision so expressively convincing that the viewer was transported into the space. This was the goal of monumental style painting. By contemplating nature, the viewer became absorbed into the order of the universe. It was a spiritual journey, one of attitude. The illusion of being there was evocative. The painting was an object for sustained meditation leading to spiritual harmony with nature. Chinese landscape paintings never reproduced the appearance of actual locations, although they were often inspired by real places. They captured the spirit of the place that was both unique and universal.

Landscape paintings require two motifs, mountain and water, derived from the two characters forming the word "landscape." Water and mountain represent yin and yang, things low and high, things flexible and rigid. Human qualities were projected on natural elements also. Bold, scrappy pines were adventurous, young gentlemen, and bent, leafless trees were wise, old men.

People are always small in Northern Song landscape painting because size is the first law in creating space. Mountains are larger than trees and trees are larger than people. Beyond these simple rules, space was controlled by personal choices about placement. Appropriately, Fan Kuan concealed his name in the leaves near the man entering from the lower right.

A notable change from Tang to Northern Song painting is the inclusion of atmosphere. Nuanced ink tones replace the hard-edged clouds and crisp details of the Tang decorative style. Mist envelops the looming mountain, shrouding crevices, and glazing planes. Expressive brushstrokes impart character to the trees, rivers, mountains, and lone building.

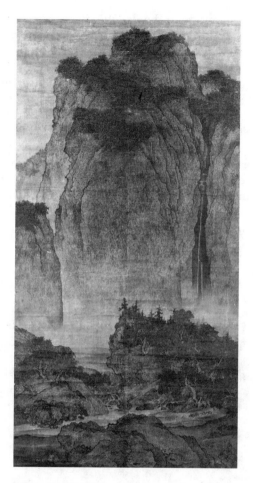

Figure 47 Northern Song dynasty
(960–1127). *Traveling Among Mountains and
Streams*, by Fan Kuan (active 990–1030), 1000;
hanging scroll; ink, slight color on silk, 81 1/2″
× 40 3/4″. National Palace Museum, Taipei

Southern Song. The last emperor of the Northern Song dynasty, Hui
Zong (reigned 1101–1125), was an accomplished painter but an inept ad-
ministrator who lost northern China to invaders. He was captured, and his
son fled south with remnants of the Song court. Although Chinese court life
resumed its former splendor, the humiliating defeat hung in memories.
Southern Song painting matured in a precarious political situation, and we
can expect a current of uncertainty to run through the landscapes. Nature be-

came the gentleman's refuge in the unsettled age, but it was a world where the harmony of the monumental style had been disrupted.

Ma Yuan (active 1150–1225) was a premier exponent of the melancholic, *lyrical style* of Southern Song landscape painting. His oval fan mounted as an album leaf, entitled *Viewing Plum Blossoms by Moonlight* (Fig. 48), is infused with lonely reflection. Gone are the stalwart young pines that had stood boldly on the cliff edge. Instead, barren plum trees, their thorns and flowers metaphors for life's fleeting pleasures, surround the man on all sides. While sitting immobile in the dangerous thicket, he gazes longingly into the night sky. Moonviewing was an ancient Chinese pastime. For centuries, buildings and gardens had been designed to facilitate advantageous views of the moon. Traditionally a group activity for the gentry, it is now a solitary activity. The gentleman is oblivious to the attendant standing respectfully behind his master. The young man, who always accompanies the scholar in a lyrical style

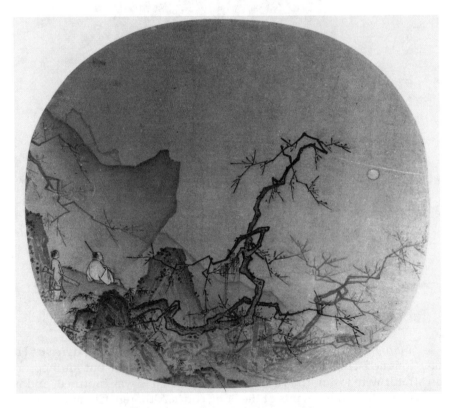

Figure 48 Southern Song dynasty (1127–1279). *Viewing Plum Blossoms by Moonlight*, by Ma Yuan (active 1190–1225); fan mounted as album leaf; ink, slight color on silk, 11 1/4" × 10 3/8" W. The Metropolitan Museum of Art, New York

painting, holds a musical instrument for the scholar's melodic response to nature.

Southern Song lyrical style paintings are narrow-focus visions where individual brushstrokes are readily apparent. It is an art of placement and framing, with near and far linked by repeating elements. The lyrical style pushes the center of interest to one side, hence the name *one-corner Ma* often used for these compositions. While the mountain commanded the space in the Northern Song composition, over one half of Ma Yuan's painting is empty. On the surface, a diagonal line slices through the composition, dividing the lower left into a congested corner that opens abruptly to the vista. The gentleman's gaze, reinforced by two large plum branches, establishes a diagonal movement in depth. Dabs of white paint on the moon and the gentleman's garment connect the sky to the earth.

Correct spatial proportions are askew in Ma Yuan's world when compared to the monumental style. Trees are large, mountains are small, and the man dominates the space with his presence. Two protuberances, edged in rich black, nearly close the gentleman's channel to the moon. While undeniably refined and excruciatingly sensitive, the world of the Southern Song gentleman is not quite right.

Chan Painting. Suppose that we take a step over the edge of the gentleman's cliff. Imagine that all Confucian order is abandoned. That would be the perspective of the Southern Song Chan painter, Liang Kai. *Chan* (Zen in Japan), a variation of Buddhism, united Buddhism with Daoism. According to Chan Buddhists, the buddha-spirit exists in everything, like the Daoists' vital energy. The important aspect of Chan is that one understands intuitively, almost accidently. Sudden revelations, unsought and unplanned, oust book-learning in the Chan worldview.

Chan nurtured an antihistory, anti-Confucian freedom that is revealed in Liang Kai's hanging scroll *The Sixth Patriarch Chopping Bamboo at the Moment of Enlightenment* (Fig. 49). A fallen gentleman-pine cuts a diagonal line across the lower left corner. The sliver of mountain, running down the left edge like a waterfall, bristles with nondescript twigs. Alone in the space, the Chan monk performs a remarkable act, slashing at the symbol of Confucian order, the segmented bamboo. By abandoning decorum and reason, he finds enlightenment. By abandoning correct proportion and controlled brushstrokes, Liang Kai surrenders to vital energy. Compared to the court painters' saturated brushstrokes, his dry-brush painting is undisciplined. To reinforce the expression, Liang Kai traded smooth silk for rough paper.

We could calculate the amount of time Liang Kai spent painting this picture in minutes, and that was the message of Chan. Creativity was swift and unpredictable. The choice to pursue the individualist's path was the artist's alone. Before taking the monk's vow, Liang Kai had earned the highest painting awards from the Southern Song court. He exchanged the cultured, nonactive life of the gentleman for the spontaneous spirit of Chan.

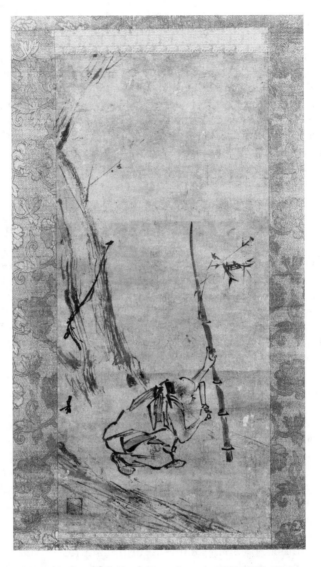

Figure 49 Chan (Southern Song dynasty 1127–1279). *Sixth Patriarch, Chopping Bamboo at the Moment of Enlightenment*, by Liang Kai; hanging scroll; ink on paper, 29 1/4″ H. Tokyo National Museum

Bamboo Painting. Bamboo was the quintessential emblem of the Chinese gentleman. It remained green through the winter, a symbol of endurance. It stood straight, but it survived because it was flexible. Its strength

was derived from its hollow center, the void through which vital energy flowed. Bamboo was segmented, like the ordered Confucian society.

Bamboo painting is considered the most difficult Chinese subject to master because the ability to dispose the repetitious shapes is a test of the artist's inventive spirit. Without the aid of detail or narrative, brushwork must carry the entire weight of the composition.

Because of these associations, bamboo painting became a popular subject during one of China's most difficult periods, the Yuan dynasty. In the thirteenth century Genghis Kahn had led hordes across the continent, cutting a path of destruction and misery from India to the shores of Japan. Kubilai Khan (reigned 1260–1294), one of Genghis Khan's sons, proclaimed himself emperor of China and adopted the dynastic name Yuan, which means "Great Beginning." Although the Chinese were spared the atrocities endured by the other conquered peoples, they were psychologically decimated by the takeover. The Great Beginning seemed to be the Great Conclusion. Bamboo painting became a battle cry among the dissenting nobility. Like the bamboo, they would endure.

An esteemed master of Yuan period bamboo painting is China's leading woman artist, Guan Daosheng (1262–1319). The deliberate, sword-stroke brushwork crossing the short handscroll (Fig. 50) makes it an excellent interpretation of a subject laden with masculine overtones. On another bamboo scroll she wrote, "Wouldn't someone say that I have transgressed?"

Eccentrics. In the fourteenth century, the alien Mongols were finally expelled and the Ming dynasty was established, to be followed by the last dynasty, the Qing, in the seventeenth century. Artistic tastes were conservative during the "Brilliant" dynasty and the "Pure" dynasty, as the names translate, respectively. The walled Forbidden City in Beijing, with its imposing halls, vast ceremonial plazas, and rectilinear alignment, encapsulates the rigid, petrified attitudes of the Chinese court.

Individualists fled the stifling atmosphere at court for the freedom of the countryside. In Chinese painting, they are referred to as the *Eccentrics.* Among the Eccentrics was the recluse Dao Ji (1641–1707). A descendent of the Ming family, he felt like an outsider in the new Chinese high society and entered a Buddhist monastery. Eventually Dao Ji abandoned his monastic vows and lived out his years as a professional painter and garden designer.

Dao Ji's novel painting *Wilderness Cottage* (Fig. 51), from a set of twelve album leaves, (Fig. 51) is a fitting conclusion to our study of Chinese art. In an inspired alliance of yin and yang, he made the mountain range swell in waves over the rickety dwelling. Lines are nervous scratches for trees, faintly touched with colored ink. As a painter and writer, Dao Ji was an articulate spokesman for artistic freedom. His most famous statement translates "I am as I am; I exist. I cannot stick the whiskers of the ancients on my face, nor put their entrails in my belly . . . I prefer to twitch my own whiskers."

Figure 50 Yuan dynasty (1279–1368). *Bamboo*, by Guan Daosheng (1262–1319), 1309; handscroll; ink on silk, 11 " H. Courtesy, Museum of Fine Arts, Boston

Figure 51 Qing dynasty (1644–1912). *Wilderness Cottage*, by Dao Ji (Shih-t'ao; 1641–1707); leaf (g) in the album of twelve leaves, *Wilderness Colors;* ink, color on paper, 15 1/2 " H × 11 1/2"W. The Metropolitan Museum of Art, New York

5

Japan

Japanese art reflects a reverence for nature, and many of its special features can be linked to the physical setting. Japan is an arc of islands embracing the Asian coast. It is a country fractured into a thousand shards of land, each with a uniquely irregular coastline. Only one fifth of the forested mountain terrain is suitable for human habitation. In a setting where volcanos, earthquakes, and tidal waves disrupt the peace, a feeling of vulnerability and an acute sensitivity to space matured.

Japan was close enough to mainland Asia to receive continental influences but far enough away to cultivate a unique vision. It always looked to China, the primary source of artistic and cultural inspiration. From China came Buddhism, Confucianism, writing, and most artistic techniques and motifs. We will discover soon that Japanese artists appreciated the accidental while Chinese artists sought perfection.

ANCIENT JAPAN

Japan maintained a neolithic culture (Jomon) thousands of years longer than China. While the Shang, Zhou, Qin, and Han dynasties rose and fell in China, Japanese lifeways remained village based. From approximately 11,000 to 300 B.C.E. people lived in pithouses, fashioning ritual and utilitarian vessels in clay. Contact with China, by way of Korea, brought Japan into the age of metal, cities, and kingship.

Shinto

Japan deferred to China on cultural matters but remained dedicated to its indigenous religion, *Shinto* (Way of the Gods). Shinto has no sacred texts or liturgy, and until the arrival of Buddhism it had no images. Shinto is an at-

titude about life, a heightened sensitivity to nature's mysteries. Spirits, called *kami*, dwell everywhere. Devotions consist of respectful appreciation conveyed through cleanliness and silence.

A building nestled in the woods at Ise marks the sacred site of the sun kami. The elegant Inner Shrine (Fig. 52) stands in the spacious courtyard of the Shinto compound. By legend, the Inner Shrine is dated to 29 B.C.E. but it is rebuilt every twenty years. Shinto craftsmen performed the sixty-first renewal in 1993. Soaring rafters break the closed silhouette and add a rectangular note to the cylindrical elements. The weighty cypress bark roof creates a feeling of enclosure. Uniquely Japanese architectural features include the building raised on poles, the unpainted natural materials, and the revealed structure.

Figure 52 Shinto. Inner Shrine, Ise; cypress wood and cypress bark.

Kofun Period

During the Kofun period (300–600/710) Japan began shedding its provincial status. Political power was consolidated in one ruling family, the Yamato. The growing wealth of the Yamato and other aristocratic families is evident in the size of earthen burial mounds, especially the distinctive keyhole-shaped mounds built for individuals of the highest rank. The largest keyhole mound rises ninety feet and, with its three surrounding moats, covers thirty-six acres.

Representational clay drainage tiles called *haniwa* (Fig. 53) dotted the exteriors of Kofun period burial mounds. Farmers with pleasant but foolish expressions, elegant ladies wearing Korean-style court costumes, and stern soldiers in leather armor were fashioned in slabs and rolls of clay with details etched in the surface.

BUDDHIST ART

The appearance of Buddhism in 538 marked a turning point in Japanese art and society. Perceived as a threat to the native kami, it was scarcely tolerated at first. When Prince Shotoku (574–622), the champion of Buddhism, stressed its moral benefits, the tide turned in favor of the new faith. Once Buddhism became the state religion, hundreds of temples appeared across the country.

The first Japanese Buddhist images were bronze statues imitating the Northern Wei style. Soon the ramrod symmetry and schematic waterfall drapery of the Chinese style were abandoned for a lighter, spiritualized style. In the wooden statue of Kannon (Fig. 54), the Japanese version of the bodhisattva of compassion (Guanyin; Fig. 42), Chinese formality is replaced by gentle vulnerability. The winsome creature is dematerialized in the manner of sculpture on a European cathedral. From a profile view the metal halo tilts over the head, initiating an S-curve that follows through the drapery.

Japanese Buddhist buildings show no deviation from their Chinese models. The Five-Story Pagoda (Fig. 55) at the venerable monastic complex, Horyuji, is an exemplary Tang dynasty building that happens to stand in Japan. Because invasions and cultural purges have destroyed almost all old Chinese buildings, historians look to the islands for a picture of continental architecture.

When we compare the Five-Story Pagoda to the Inner Shrine at Ise, the differences between Chinese and Japanese design emerge. The pagoda stands on a masonry base, while the Ise shrine is raised on stilts. Elaborate brackets, a hallmark of Chinese architecture, project from the walls to support the flaring eaves. The bracketing system adds an ornate note that would be out of place on the austere Shinto shrine. Paint and goldleaf enhance the decorative appeal of the Chinese transplant, as do the clay tiles on the roofs. Where

Figure 53 Kofun period (300–600/710). Haniwa farmer; clay, 36
3/8" H. Tokyo National Museum

Japanese design seeks simplicity, the Chinese style delights in complexity.
Another difference between the two Asian styles is the disposition of
architectural elements. Four equidistant stairways lead to four identical doors
on the pagoda, while a single stairway rises to one entrance on a long side of

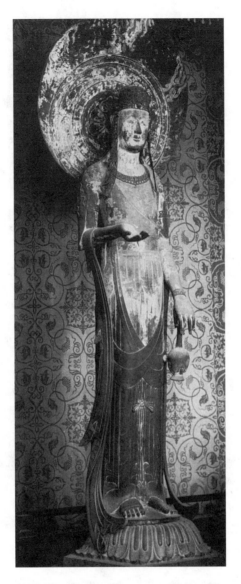

Figure 54 Kudara Kannon, early seventh
century; painted wood, metal, 6'11" H.
Horyuji Treasure House, Nara

the Ise shrine. The asymmetric alignment of the main structures at both
Horyuji and Ise is distinctly Japanese, in contrast to the symmetric placement
preferred in Chinese space planning.

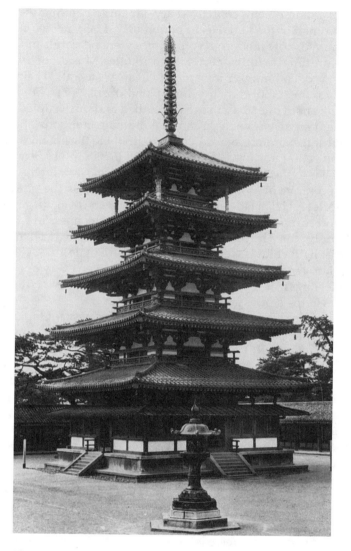

Figure 55 Five-Story Pagoda, Horyuji, after 670; 122' H.

HEIAN PERIOD PAINTING

In 898 Japan severed diplomatic ties with China. With the atmosphere cleared of persistent Chinese influence, the national Japanese painting style came into focus. By the year 1000 a unique pictorial vision, soon called *Yamato-e* (Japanese picture), had crystallized.

Like its Chinese Song contemporary, Japanese painting was a courtly style. It blossomed in the Late Heian period (897–1185), named for the capital city, Heiankyo, now modern Kyoto. Times were peaceful, and prosperity made for leisure time to cultivate artistic sensibilities. Music, poetry, and painting were forms of communication among Heian aristocrats. Their lives were exceptionally refined, but they lived in splendid isolation. With only themselves to think about, they became self-absorbed and preoccupied with manners. Strict etiquette suppressed normal human emotions. Beneath the gorgeous but stiff exterior grew an acute sensitivity to the nuances of feelings. Prolonged reflection nurtured an awareness of life's frailties. A melancholic attitude, similar to the Southern Song, entered Japanese painting.

This decorative art, with its air of resignation, was the product of the woman's world. A Heian lady spent her life indoors moving through covered walkways and corridors that linked the numerous chambers in a Heian villa. Because the only men who could see her were her father and husband, portable screens and hanging blinds were set in place when a male guest was received. Despite her cloistered existence a Heian lady was given every opportunity to express her feelings in writing, painting, and music. Her most private thoughts found outlets in the stories and pictures she composed.

Our example of Yamato-e painting is from a classic of Japanese literature, *The Tale of Genji*, a romance novel written around 1000 by Lady Murasaki Shikibu (died around 1015), a lady-in-waiting to the empress. Figure 56 shows a nonevent, Lady Naka-no-Kimi having her hair combed. The incidental episode is a prelude to doom. Attending at the toilet is her half-sister, Ukifune. Through circumstances of birth, beautiful Ukifune was a social outcast. Lady Naka-no-Kimi agreed to take the wretched young woman into her home, not anticipating that Prince Niou, an irresistible man with a cavalier attitude toward women, would be attracted to her. At the toilette he spied Ukifune and soon put her in a compromising position. In grief and humiliation, Ukifune eventually drowns herself in a river.

Although Niou is not shown in the painting, having returned by this time to the Imperial Palace, we sense his lingering presence in the open sliding screen. The vertical slice of emptiness in the center, runing from the open door through the hanging screen, is the tension-packed section. The landscape painted on the sliding screen, the cascading ribbons on the hanging screen, and the black river of hair prefigure Ukifune's watery death.

On first consideration the poignant narrative may seem neutralized by the distinctive Yamato-e painting style. It is highly decorative and two-dimensional, created with thick opaque paint layered over a preliminary ink drawing. A shorthand stroke for nose and brows denotes each stylized face. Bodies are lost beneath heaps of fabric. A disorienting space results from the elevated viewing angle. To simulate a voyeuristic perspective, Yamato-e painters created interior-exterior views by removing the roofs. Diagonal screens and balconies flatten the space, contributing to the claustrophobic feel-

Figure 56 Late Heian period (897–1185). *Tale of Genji*, detail *Azumaya I*, twelfth century handscroll; ink, color on paper, 8 1/2" H. The Tokugawa Art Museum, Nagoya

ing. Nothing is revealed completely. Fragments imply that the whole picture has yet to emerge.

A second type of Late Heian painting used monochrome ink. In appearance it is closer to contemporary Chinese painting than the hard-edged, polychrome *Genji* picture. But Japanese artists explored physical and psychological interactions, while in China the theme was the solitary experience in nature. The irreverent attitude of Late Heian ink painting makes it unlike continental or courtly Japanese counterparts.

Few artists were as flippantly disrespectful as the abbot of Kozanji monastery, Toba Sojo (1053–1140), who is traditionally credited with the *Frolicking Animals* paper handscroll (Fig. 57). The handscroll has no text, and the most cursory glance shows why a written narrative was unnecessary. Animals parody the Buddhist clergy and its perceived sham devotions. The dower-faced frog-buddha performs the mudra of reassurance for the monkey-monk chanting before the lotus throne. In the upper right, a compassionate monkey-monk is overcome with ecstasy and, slightly outside our detail, an aristocratic fox-lay-Buddhist sits demurely behind its fan while an ascetic cat intones the rosary. Only the wise owl in the Tree of Enlightenment looks out knowingly. To the painter, human foibles were silly, not tragic. The brushwork contributes to the satirical bite of the painting. Lines are positive, dynamic marks that interpret the main points. The emphatic tree is painted in black ink, the insubstantial frog-buddha rendered in transparent washes.

Figure 57 Late Heian period (897–1185). *Frolicking Animals*, detail, possibly by Tobo Sojo twelfth century; handscroll; ink on paper, 12 1/2" H. Kozanji, Kyoto

KAMAKURA PERIOD SCULPTURE

While Late Heian painters explored psychological realism, artists of the Kamakura period (1185–1333) excelled in the depiction of physical realism. The statue of Shunjobo Chogen (Fig. 58) is a photorealist presentation of the old Buddhist monk. With ruthless honesty, the artists carved the sunken eyes and sagging, paper-thin flesh of a man nearly ninety years old. Spirit, conveyed in his determined expression and strong hands clicking the rosary beads, gives his frail body great strength. How different is this presentation of a devout Buddhist compared to the caricature of Buddhists in the Late Heian handscroll.

The possibility exists that several individuals carved the Shunjobo Chogen portrait. In the Kamakura period, statues were often made of several pieces of wood, a method called *multiple-block sculpture*. To overcome the warping and cracking that resulted when a single block of wood was used, individual blocks were carved and then assembled into the final statue. In the workshop method, artists specialized in faces, hands, or elbows.

Heroes of the church and the state were memorialized in Kamakura art. Shunjobo Chogen was revered for his efforts to restore monasteries destroyed in the civil war that had ended the Heian period and begun the Kamakura. The individual who benefitted most from the civil war was Minamoto Yoritomo (1147–1199), whose stronghold was Kamakura, near modern Tokyo. When his troops seized control of the country, the emperor appointed him the military dictator (*shogun*). From 1192 until 1868 Japan was ruled by a shogun,

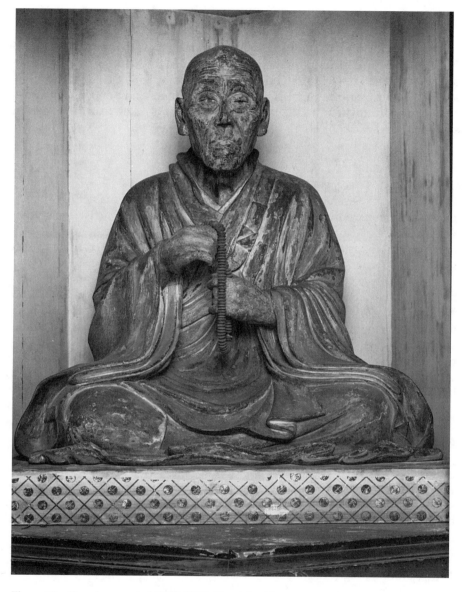

Figure 58 Kamakura period (1185–1333). Shunjobo Chogen, early thirteenth century; painted wood, 32" H. Shunjodo, Todaiji, Nara

and the emperor was a figurehead. Samurai soldiers pledged their allegiance to the shogun, and their no-frills warrior mentality encouraged Kamakura realism.

ZEN AND THE WAY OF TEA

Also appealing to the samurai's spartan life was *Zen Buddhism*, which had appeared in China under the name Chan. Zen flashes of insight were like swift sword slashes; prolonged meditation complemented the samurai's physical self-discipline. Samurai were often painters and poets but their aesthetics tended toward simplicity. Understatement is a key feature of Zen-inspired Japanese art.

Zen Painting

Zen monk Sesshu Toyo (1420–1506), the undisputed master of Japanese monochrome ink painting, is the country's most esteemed artist. He studied with a Zen abbot-painter before embracing the life of a recluse. Samurai sought his company in his mountain retreat, a lonely refuge that probably resembled Dao Ji's wilderness cottage (Fig. 51).

Sesshu mastered many painting styles, creating landscapes in a dry brush, scratchy style, and in a difficult drenched ink technique called *haboku*, which translates as "splashed" or "broken" ink. The hanging scroll in Figure 59 is his finest effort in the minimalist haboku method. All necessary landscape motifs are present, but we must study the painting carefully before the mountains and water coalesce. With the briefest gestures Sesshu included a village, two figures and a boat. Tonal ranges are extreme, from deep blacks to barely perceptible mists of gray. Apparently, Sesshu considered this soft brush painting one of his major achievements. Above the landscape he wrote a synopsis of his life leading up to its creation. He mentions his visits to Chan monasteries and the names of his teachers. Other Zen monks added inscriptions praising the painting. Sesshu created the painting for one of his students, a graduation gift to a young monk-painter.

The arbiters of taste in the Ashikaga (or Muromachi; 1338–1573) and subsequent Momoyama (1573–1615) periods were samurai warriors and Zen monks. From their cultural alliance arose the Japanese meditation garden and the distinctive architecture and ceramics of the tea ceremony.

Garden Design

Many types of gardens were constructed in Japan. We would enjoy a *pleasure garden* by strolling along paths of irregularly placed stepping stones in a cinematic experience where the pace and framing are carefully controlled. Many vistas were giant replicas of famous paintings or miniature versions of famous scenic locations. Pines were trained, their limbs anchored with ropes to simulate ancient trees. The countryside was scoured for boulders with evocative shapes.

Figure 59 Ashikaga (Muromachi) period (1338–1573). *Landscape*, by Sesshu Toyo (1420–1506), dated 1495; hanging scroll; ink on paper, 58 1/4" × 12 7/8". Tokyo National Museum

Meditative gardens are associated with Zen. We would contemplate the space from the perimeter, like a viewer experiencing an ink painting. The mediative garden was a three-dimensional abstraction of the entire world.

The plan for the meditative garden at Daisenin (Fig. 60) is attributed to Kogaku Shoko (1464–1548), the founder of the Zen monastery where it is located. Collaborating with Soami, whose ink paintings hang inside the temple, the abbott composed the elements against a white wall simulating the paper background of an ink painting. Within a tiny space, twelve-feet-wide and forty-seven-feet-long, he orchestrated stones to rise like mountain ranges and sand to flow in a river rippling near imaginary shores. One horizontal stone suggests a boat, another a bridge that no one can cross. Small stones conjure images of fish and turtles in the raked sand water. Pines and moss add the only greenery. The Daisenin garden is a tranquil playground for the mind.

The Arts of Tea

For centuries Chan monks had used tea to stay alert during meditations. In Japan consuming tea was elevated to a fine art, formalized in the secular Way of Tea (*chanoyu*) or the *tea ceremony*, as it is popularly called. Practitioners

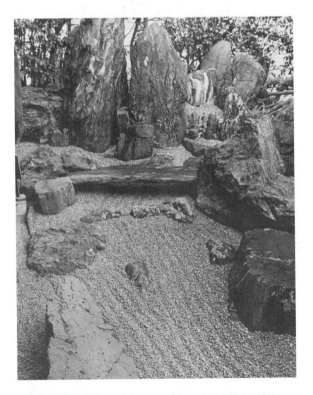

Figure 60 Askikaga (Muromachi) period (1338–1573). Garden of Daisenin, possibly by Kogaku Shuko (1464–1548); 12′ × 47′

of the art of tea are quick to point out that it is not a ceremony but a way of savoring the company of friends while respecting a code of etiquette. Preparing, presenting, and receiving the thick, green tea require years of special training.

Every estate had a building reserved for the consumption of tea. Rough hewn timbers were exposed inside and outside the rustic teahouse, a poverty by choice. Low doors required participants to enter the tiny building humbly, a deference by choice. The space was intimate, every action subdued. One hanging scroll or a single blossom displayed in an alcove (*tokonoma*) preoccupied attentions all evening. The intention was to make participants acutely aware of beauty in the smallest things. As the great tea master, Sen Rikyu (1522–1591), outlined them, the four principles of the Way of Tea are harmony, purity, respect, and tranquility.

The first tea wares were elegant continental imports, but Sen Rikyu preferred decrepit-looking pottery, such as *Shino ware* with its thick, white glaze

Figure 61 Momoyama period (1573–1615). Shino water jar called *Kogan*, late sixteenth century; glazed stoneware, 7″ H. Hatakeyama Memorial Museum, Tokyo

and desirable pocked surface. The water jar entitled *Kogan* (Fig. 61) summarizes the Zen tea aesthetic. Beauty was perceived in rough and irregular shapes. Sad, lonely looking objects were prized. Kogan, meaning "Bank of an Ancient Stream," is decorated with unpretentious river grasses. The element of chance, which always exists in the creative process, is evident in the irregular rim, lopsided contour and crunched base. In comparison to the perfect Chinese vessel (Fig. 37), Kogan looks like it happened naturally.

SCREEN PAINTING

Alongside the austere Zen visions were the opulent expressions of the *decorative style screen* painters. Both aesthetics had their proper places in Japanese life. The decorative style screens were at home in the samurai's castle, never in his teahouse.

A notable change in the new painting is its monumental size. Architectural scale pictures rivaled but never ousted the smaller hanging scrolls and handscrolls. Two popular formats were the *sliding screen*, a fixed painting created for a specific location, and the portable *folding screen*. Both were fashioned over a wooden lattice covered with small sheets of pasted paper. On this foundation, a painting surface of paper or silk was fastened. Sheets of thin silver and gold provided the ground for the brightly colored opaque paints, silver and gold paint, and ink.

A pair of six-fold screens (Fig. 62) by Sotatsu (active 1600–1640) exemplifies the decorative style screen tradition. He faced the task of composing twelve vertical compositions, complete in themselves, two horizontal compositions, and a final long picture incorporating all the parts. Examining each fold shows how successfully he designed the units.

Characteristic of products by the decorative style screen painters, Sotatsu's work represents a return to the Late Heian Yamato-e style. Aspects of the *Genji* handscroll have been purified by the Zen temperament. Colors are bolder, the disposition of shapes and spaces more emphatic. Yamato-e outlines disappear in favor of *boneless style* painting, which forgoes lines to abut color against color. The foaming waves, on the other hand, unite fluid ink brushwork with silver paint.

Sotatsu drew inspiration from classic Heian literature. Besides the *Genji*, he painted passages from the *Tales of Ise* (950), a collection of poems about a Heian nobleman. The subject of the six-fold screens has been traced to an episode in the *Tales of Ise* in which a man, who has been banished from Kyoto, stands dejected on the shore, pondering the distance separating him from his home. We cannot find the nobleman represented in the painting because Sotatsu has us take his place. What we are experiencing is his hallucinatory vision of the sea. In the *Genji* painting we were mere spectators. Now we are the character.

Decorative style screens helped illuminate dark interiors in the fortified

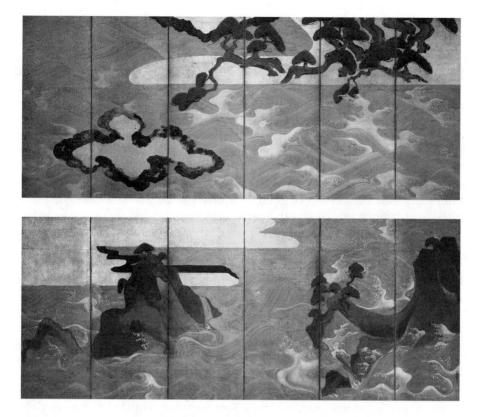

Figure 62 Momoyama (1573–1615) and early Tokugawa (1615–1868) period. *Waves at Matsushima*, by Sotatsu (active 1600–1640); pair of six-panel folding screens (top, left; bottom, right); ink, color, gold leaf on paper, each screen 59 7/8″ × 140 1/2″. Courtesy of the Freer Gallery of Art, Smithsonian Institution, Washington, D.C.

castles that appeared during the Momoyama period. It was a brief but tempestuous era when neither the emperor nor the shogun could maintain peace, and rivalries between feudal lords erupted in civil war. One personality, the cultivated but ruthless samurai Toyotomi Hideyoshi (1536–1598), dominated the transitional age. Although an avid practitioner of the Way of Tea, Hideyoshi compelled tea master Sen Rikyu to take his own life.

WOODBLOCK PRINTS

When Tokugawa Ieyasu (1542–1616) defeated Hideyoshi loyalists, he inaugurated an era of internal stability, the Tokugawa period (1615–1868). Around the administrative center, Tokugawa Castle, grew the boomtown of Edo (modern Tokyo). Feudal lords expended fortunes on mansions for their

94

CHAPTER 5

families, who were required to live six months of the year in the capital. Gradually, the agrarian economy was urbanized, the military society pacified.

A new class of art patrons, the urban merchants, appeared in the prosperous Tokugawa period. They replaced the samurai, whose fortunes waned when their services became unnecessary in the peaceful climate. Merchants and artisans, traditionally perceived as the lowest members of society, became affluent, influential middle class citizens. Their tastes in art and entertainment ensured the success of the woodblock print and the activities that inspired them.

Samurai were forbidden to enter the licensed "pleasure quarter" of Edo, the Yoshiwara district, a walled enclave set aside for merchant-type entertainments. But they could be seen, disguised in broad-brimmed hats, mingling with merchants at the theaters and brothels. For the tourists, artists created inexpensive souvenirs, pictures of famous prostitutes and actors. The thematic repertoire is called *ukiyo-e*, which means "picture of the floating world." The pleasure district was a place of insubstantial sensation, the arena of momentary stimulation. It lacked tradition, permanence, and purpose, but it was, nevertheless, immensely interesting.

Our selection from among the myriad images to come out of this environment was inspired by the popular theater, *Kabuki*. Men, who specialized in male or female roles, performed in the bawdy melodramas and bombastic brawls. Pictures of leading actors, especially members of the Ichikawa clan, were avidly collected by their fans.

For decades Torri family artists monopolized the production of Kabuki prints. The Torri studio, founded by a Kabuki actor, acquired exclusive rights to theater-programs, and it generated many illustrated books and single-sheet prints. The hand-colored woodcut print (Fig. 63) by Torri Kiyotada (active 1719–1750s) captures the violent gestures and contorted expressions that were Ichikawa actors' specialties. Against a neutral background, typical of eighteenth century theatrical prints, the actor holds the "sustained pose" that thrilled Kabuki audiences. The unrealistic mannerisms of "rough stuff" Kabuki are communicated by the angular folds of the "large sleeve" costume. In the manner of the actor, the artist used exaggeration for dramatic effect.

Producing a *woodblock print* was a corporate endeavor requiring the expertise of publisher, designer, carver, printer, and retailer. The medium, traced to fourth century China, was traditionally reserved for Buddhist texts. In 1658 the first black-and-white ukiyo-e prints were made. When color was used on the early prints, it was applied by hand. *Multicolor woodblock* technology was introduced in the 1760s. Dozens of colors, each applied with a separate woodblock, are seen in multicolor (*brocade*) prints.

Woodblock printing mass produced inexpensive pictures by transferring an image from a wooden matrix to a piece of paper. Editions ran into the tens of thousands. Once the publisher had surveyed the market for a popular theme, he commissioned a design from an artist. His ink drawing was trans-

Figure 63 Tokugawa period (1615–1868). *An Actor of the Ichikawa Clan*, by Torii Kyotada, ca. 1719–1740; hand-colored woodblock print on paper, 11 1/4″ × 6″. The Metropolitan Museum of Art, New York

ferred to thin paper, which was glued on a block of wood. A carver chipped away the wood surrounding the ink lines to create the *key block* that aided in the difficult task of aligning blocks for multicolor prints. The printer brushed the raised areas with color, and covered the block with a sheet of strong, absorbent paper. Rubbing the back of the paper transferred the color to the print. The final printing was the key block, which overlaid black outlines.

The public never tired of provocative ukiyo-e subjects, but in the nineteenth century an old painting theme, the evocative landscape, entered the world of prints. In 1823 master printmaker Katsushika Hokusai (1760–1849) began a series of prints, *Thirty-six Views of Mount Fuji*, of which *The Great Wave* (Fig. 64) is the most famous. Under the influence of European painting, Hokusai juxtaposed foreground and background in a novel manner for Far East Asian art. He restricted the color to shades of Prussian blue, a recent import to Japan. Even the traditionally black outlines are blue.

Throughout the series the auspicious kami site, Mount Fuji (Eternal Life), is the backdrop for human activities. In the traditional union of yin and yang a surging arc of foaming water rises to embrace the mountain. The fishermen are tossed about by the sea that wells up in a giant claw, but they seem respectful of nature's power. Safety exists in a harmony with nature.

Figure 64 Tokugawa period (1615–1868). *Great Wave*, from *Thirty-six Views of Mount Fuji*, by Katsushika Hokusai (1760–1849), 1823–39; colored woodblock print on paper, 10 1/8″ × 14 3/4″. Courtesy, Museum of Fine Arts, Boston

6

Oceania

Oceania is a term for the islands that sprinkle the seas around Asia. Most are little chips of land, like the Japanese archipelago, but one is a landmass of continental proportions. Tahiti, Fiji, and the Hawaiian Islands are a few of the famous, exotic locales of Oceanic art. Our selections from New Guinea, Australia, and New Zealand must represent the artistic achievements of the diverse, individualized Oceanic cultures.

Unlike the nearby island civilizations of Japan and Java, the Oceanic communities on the Pacific Rim existed outside the sphere of Indian and Chinese influence. In some regions, a neolithic lifeway is still maintained. While the mechanics of their everyday lives were, and in some cases remain, rudimentary by modern standards, the arts and worldviews of Oceanic peoples are highly sophisticated expressions with long traditions.

Artistic similarities are evident in the Oceanic communities. Temporary, portable art has been the norm. Body ornamentation and wooden sculpture have been the preferred formats. Subjects address clan affiliations, ancestral veneration, fertility, and warfare. The natural environment has provided the artistic materials and many symbolic motifs, including animals and insects.

NEW ZEALAND

New Zealand (part of Polynesia), situated off the southeastern coast of Australia, is home to the Maori people. They had been living on the island for at least seven hundred years by the time Europeans came in 1768. The Maori were militaristic village-dwelling fishermen; chieftains governed the socially stratified communities. Dozens of clans aggressively defended their territorial boundaries in ferocious intertribal conflicts.

Maori war canoes were launched from the palisaded coastal villages. The monumental transports, capable of holding forty to eighty warriors, were also vehicles for artistic expression. The dugout canoe was protected by symbolic carvings on the prow (Fig. 65) and stern. Our example displays a fearsome head with lolling tongue. Two large spirals whirl with the ocean energy of Hokusai's *Great Wave* (Fig. 64). A *Kaitiaki* or ancestor, on the bottom, and another a protective ancestor, facing the warriors, unite life and death symbolism. Tiny curved-beak bird heads (Manaia), symbolic of life and death, peck at the spirals and the connecting bars that stabilize the openwork spirals. Like early medieval European manuscript paintings and Islamic ornamentations, Maori designs are intricate patterns that are both symbolic and decorative. Pierced wood imparts a fragile appearance to the frightening imagery.

IRIAN JAYA, NEW GUINEA

The Asmat people live in the western half of New Guinea, in the coastal swamps and highland forests of Irian Jaya (part of Indonesia). Clans are governed by chiefs, and like the Maori, they were a warlike people before Europeans arrived. Only after World War II did the village-dwelling hunter-gatherers sustain contact with people outside their island world. At the end of the twentieth century, the Asmat represent one of the world's last surviving neolithic cultures.

The inhospitable land of Irian Jaya probably encouraged the mysterious, fearsome quality of Asmat art. Two related themes, ancestor veneration and headhunting, supplied the subjects and impetuses for art. Many symbols appearing in connection with these themes derive from the Asmat creation story.

Figure 65 New Zealand (Maori). War canoe prow, eighteenth century; wood, 45 1/4" L. Museum of New Zealand Te Papa Tongarewa, Wellington

Their primordial ancestors were carved from trees by the Asmat culture hero, Fumeripits. Reflecting their arboreal ancestry, the people call themselves *We, the tree people* (Asmat-ow). In the tree metaphor, fruit symbolizes the human head. Fruit-eating animals, including birds and fruit bats, are symbols for head-hunting activities. The female praying mantis, which consumes the head of the male after mating, is another Asmat motif. Because the works of art are carved from wood, the tree itself is not included in Asmat imagery.

Headhunting was associated with male initiation rites. Blood of the de-capitated head mingled with that of the newly circumcised boy, energizing the ancestral spirits and the young warrior with the life force tapped from the dead enemy. Losing a clan member to an enemy's knife required that his spirit be avenged with a head taken from the offending clan. Large, carved spirit poles (*mbis*) were also set up as receptacles for the wandering spirit.

During special shield feasts men shaped war shields from planks of man-grove tree root and embellished them with painted relief carvings of military and virility motifs. The mystical protection provided by the images was just as important to the warriors' well-being as the physical protection provided by the slab of wood. The contour of the left shield in Figure 66 has phallic overtones. Stylized fruit bats repeated along the central axis supply the head-hunter symbolism. The middle shield is surmounted by an ancestral head carved in-the-round. Carved in relief on the top and bottom are male and fe-male ancestors. A diminutive head, articulated genitals, and dangling, elon-gated limbs imitating the praying mantis are features that identify the unique Asmat interpretation of the human body. The splayed position, also evident in the male ancestor on the right shield, is considered a protective pose. Bird-like C-shapes and S-shapes with ancestral connotations add potent symbols uniting the main elements in the composition. Since headhunting is now for-bidden, the Asmat create war shields for art collectors.

ABORIGINAL AUSTRALIA

Due south of Irian Jaya is the home of nomadic Aboriginal Australians, the continent that eighteenth century European explorers called "the empty land". Like the Asmat, Aboriginal Australians defend one of the last bastions of neolithic life. Their paintings are among the world's oldest living artistic traditions. Pictures created yesterday bear a striking resemblance to Australian rock paintings that are fifteen thousand years old.

Aboriginal Australian artists still create paintings on behalf of the entire community. They are responsible for perpetuating the epic adventures of the supernaturals contained in a system of stories called the *Dreamings*. Events that inspired the stories took place in the "dream time," the remote, mythical past. *Mimi*, thin spirits who gave the Dreamings to the Aborigines, are often shown in art. They are similar in appearance to the Asmat praying mantis figures.

As custodians of the Dreamings, artists assume responsibility for pre-serving communal traditions. In their egalitarian society, status is determined

Figure 66 Irian Jaya (Asmat). War shields, twentieth century;
painted wood. The Metropolitan Museum of Art, New York

by the amount of knowledge one has acquired. Although Dreamings episodes
may not cross territorial boundaries, they are linked in a continent-wide cul-
tural network. Regional styles identify the geographic origin of a Dreamings
painting.

Bruce Nabekeyo (born around 1949) is an Aboriginal artist in northern
Australia. Within the Dreamings sequence he safeguards a creation story of
the Rainbow Serpent, Yingarna (Fig. 67). In the traditional Aboriginal
metaphor of birth, Yingarna swallows humans, whom she will transform by
regurgitation. The x–ray view of her body, also typical of northern Aboriginal
art, allows us to see several activities taking place simultaneously. Yingarna's
waterhole home is indicated by the water lilies on her back.

Vital information in the Dreamings episode is recorded with firmly out-
lined shapes disposed in an overall composition that fills the picture plane
from edge to edge. Crosshatched patterns (*rarrk*), characteristic of northern
Australian painting, are the personal property of individual clans.

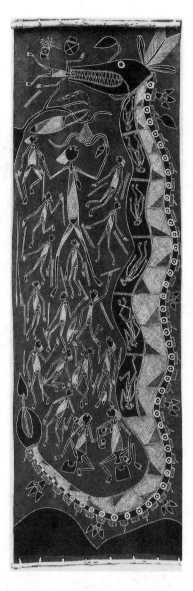

Figure 67 Aboriginal Australia. *The Rainbow Serpent, Yingarna*, by Bruce Nabekeyo (born 1949); color on bark. National Gallery of Australia, Canberra

The technique of painting earth tones on prepared sheets of bark is also indicative of a northern Australian origin. In composing the picture, the artist rotated the bark as he held it on his lap, so there was no fixed viewing angle.

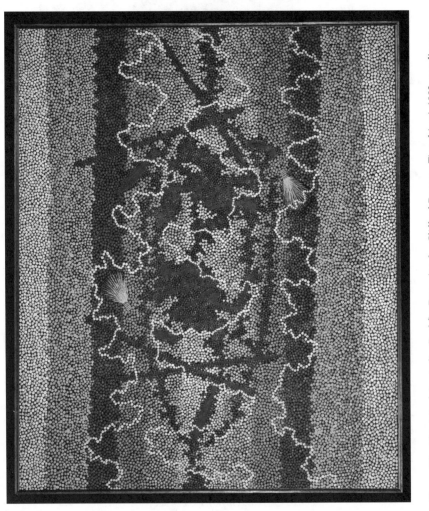

Figure 68 Aboriginal Australia. *Bushfire Dreaming*, by Clifford Possum Tjapaltjarri, 1982; acrylic on linen, 32 ³/₈″ × 40 ³/₈″ Art Gallery of South Australia, Adelaide

Because the process is more important than the product, bark paintings are ordinarily discarded after use. The first examples were collected in the 1830s, but the antiquity of the tradition is probably much older.

Paintings by Clifford Possum Tjapaltjarri (born around 1943) represent the regional style practiced in the deserts of the Northern Territory, particularly around the city of Papunya. The highly abstract style, its veiled symbols intended for an audience initiated in the Dreamings sequence, is apparent in *Bushfire Dreaming* (Fig. 68). The subject is the death of two brothers, trapped in a fire set by their father to punish them for greed and lack of filial piety. The luminous, patched background represents the path of destruction; red indicates flames, gray is the smoke-filled atmosphere, and the wavy lines represent smoke carried by the desert winds. Having established the setting, Clifford Possum introduces the symbolic narrative motifs, the skeletal remains, the abandoned weapons, and the bundles of bush with which the young men fought the flames. The interplay of curved and straight lines with light and dark textural reversals is as compelling as the Dreamings episode which inspired the painting. A lustrous field of dots, invigorating the surface with sparkling patterns, has become a hallmark of Clifford Possum's style, as have the pair of skeletons and horizontal division of the picture plane.

Clifford Possum is one of a growing number of Aboriginal artists who have, since 1971, chosen synthetic paints and commercial fabrics for their paintings. Acrylic paints enabled him to achieve the brilliant color characteristic of the desert style, but the European easel held no appeal, and he continues to compose in the manner of drypaintings, with the linen on the ground. Clifford Possum was introduced to watercolor and acrylics paint by Geoffrey Bardon, a European school teacher in Papunya. Bardon encouraged the adults to paint murals in the school and soon supplied them with acrylics. During his tenure, the Papunya Tula Artists' Cooperative, for which Clifford Possum continues to create many works, was founded to safeguard the interests of the painters and to bring their works to an international community.

7

South America

For thousands of years before Europeans arrived on their continents, ancient Americans built thriving cities and sprawling ceremonial complexes. They traded textiles, precious metals, and ceramics across long-distance trade routes through the mountains, deserts, highlands, and rainforests of the New World. Therefore, the ancient arts of South America, Mesoamerica and North America often share similar themes and styles.

The term *Andean* pinpoints the heartland of ancient South American civilization. Andean cultures flourished in a terrain of abrupt extremes in the modern countries of Colombia, Bolivia, Chile and, most important, Peru. The Andes mountains separated the coastal region from the Amazonian rainforests, dividing the western urban people from the eastern forest people. The narrow coastal desert and the highlands of the Andes supported the major civilizations. Oasis towns with irrigated fields of corn and beans were characteristic of the desert communities. In the Andes, the highlanders herded llama and cultivated potatoes in terraced fields.

CHAVIN SCULPTURE

The early phase of Andean civilization is summarized in works discovered at the ceremonial site Chavin de Huantar in the northern Peruvian highlands. Founded around 1000/850 B.C.E. it experienced its greatest flowering between 600 and 300 B.C.E. Many structures are granite-faced earthen platform mounds perforated by stone-lined corridors.

The congested surface of the Raimondi Stone (Fig. 69), a low relief stone sculpture that once adorned a temple at Chavin de Huantar, makes an initial reading of the image difficult. This aversion for blank spaces (horror vacui),

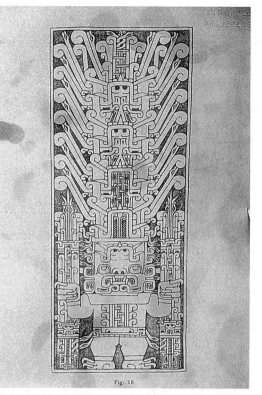

Figure 69 Chavin, Peru. Raimondi Stone, 1000–600
B.C.E.; diorite, 6'6" H. Museo Nacional de Antropologia
y Arqueologia, Lima

typical of ancient American art, should recall a similar surface treatment on
the Chinese ritual bronze vessel (Fig. 39). A frontally posed, standing crea-
ture, named the Staff God because it holds two scepters, monopolizes the
space. In the assemblage of transforming animal and human parts, we can
identify serpents along the perimeter, in the hair, on the belt, and atop the two
staffs. Feline attributes include claws, drooping fanged mouth, and cat faces
on the bottom of the scepters, just below the Staff God's elbows. Pupils are
positioned high on the eyeball, separating the head into two faces. The sec-
ond face, looking upward through the headdress of telescoping bird-beaked
faces, creates a split image that has led some specialists to suppose that the
Raimondi Stone was originally imbedded in the floor.

Penchants for linear design, frontal pose, horror vacui, and transposing
reptilian, avian, and feline elements are features of early Andean art.
Disseminated by commercial trading, Chavin culture united highland and
desert people with shared visual expressions of abstraction and supernatural
imagery.

PARACAS TEXTILES

From around 500 B.C.E. southern desert Paracas artists (1400/900–1 B.C.E.) interpreted the Chavin style in the textile medium. In South America weaving had predated ceramics by six thousand years, the earliest examples dated around 8600 B.C.E. Paracas textiles are fine cotton fabrics woven on a backstrap loom, a portable loom with one end tied around the weaver's waist and the other around a pole. In a labor intensive exercise, Paracas fiber artists embroidered both the design and the background color over the woven cloth.

The embroidered edge of a Paracas mantle (Fig. 70) was worked in the *block-color style*, recognized by shapes filled with solid colors. Outlines and interior details were drawn in thread, then the ground cloth was covered with tiny parallel stitches before color was sewn into the shapes. A clear figure-ground relation is established, but deciphering the Ocelot Being, named for its thick whiskers, requires the patience we mustered for the Raimondi Stone. Its position is an interesting alternative to the frontal pose of the Staff God. Flattened and bent like cardboard, the Ocelot Being is oriented above and outside the pictorial space. Placed in the unorthodox position of looking down on the creature, we see the bottoms of its feet, the back of its torso, and the front of its face; it abounds in dislocated faces and animal parts. A long streamer with snake and cat elements flows from its headdress. It holds a trophy head in one hand and a snake in the other.

The arid desert climate preserved Paracas textiles, which were interred with the dead in *mummy bundles*. The untreated corpse was wrapped in coarse cotton cloth and placed in a basket along with fine textiles, including headbands with streamers, tunics, and mantles. As the most valuable commodity in ancient South America, fabric was the currency, the badge of authority, the emblem of status, and the guide to family affiliations. When the Spanish in-

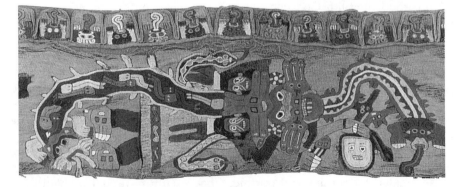

Figure 70 Paracas, Peru. Embroidered mantle, detail, 300–100 B.C.E.; cotton, length of entire fragment, 130". Goteborgs Etnografiska Museum, Sweden

vaded the highlands in the sixteenth century, Andeans accused them of stealing cloth.

MOCHE CERAMICS

Once accustomed to Chavin and Paracas abstraction, we may find the naturalistic Moche style something of a surprise. Its lively compositions and believable figures represent another facet of ancient American art.

Moche culture, also called Mochica for the language spoken in the region when Europeans arrived, is dated between 150 B.C.E. and 800. From its heartland, the northern coastal valley from which its name derives, Moche culture spread some two hundred miles along the Peruvian coast. In the main city, also called Moche (Cerro Blanco), builders constructed adobe houses on terraced platform mounds and huge adobe temple mounds, including the largest mound in South America, the Pyramid of the Sun.

Moche culture is known primarily through its funerary arts. The specially crafted items in clay, feathers, metal, and wood have been recovered from tombs in and adjacent to ceremonial mounds. Clay was the material of choice. Moche vessels were handbuilt using coiling, modeling, and press-molding techniques, often in combination. Red or cream color designs were painted on a complementary ground color. The unique format was the *stirrup-spout vessel*, recognized by its semicircular handle with attached tubular spout.

Many Moche funerary vessels are miniature sculptures with spouts, the bodies of effigy vessels formed into representational shapes. Some are darling, others outright bizarre. Men, animals, vegetables, buildings, and deities abound. Anthropomorphic (humanoid) effigy vessels include the "parts-portraits," a head, hand, or penis, and full-length figures.

Portrait vessels were molded and modeled, an approach similar to the one used by Chinese artists creating the clay army of Qin Shih Huang Di (Fig. 38). Figure 71 shows the degree of realism achieved by Moche artists in this format. Using clay like a camera, the ceramist fashioned a convincing physical and psychological likeness that has the immediacy of a snapshot. The spontaneous expressions, a laugh or grimace, and the contemplative countenances in Moche art are unlike any of the emotionally neutral poses we have encountered throughout this study. The discovery of identical faces in different tombs suggests that the Moche portraits represent someone other than the deceased.

In another group of Moche vessels the smooth, globular chambers were decorated with two-dimensional narrative paintings. They were the painter's vehicles for action subjects. Some examples combine narrative painting and three-dimensional images modeled on the spout.

The artist who fashioned the vessel in Figure 72 combined two- and three-dimensional versions of a familiar theme in Moche art. It depicts Moche messengers wearing distinctive kilts with wave pattern, lima bean belts, headdresses with feline emblems, and circular nose ornaments. The proportions

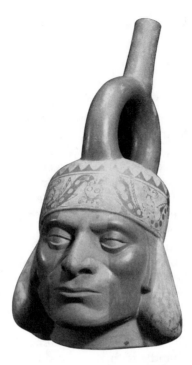

Figure 71 Moche, Peru. Portrait
stirrup-spout vessel, ca. 500; painted
clay. Courtesy of The Art Institute of
Chicago

of the modeled three-dimensional messenger, emphasizing head and eyes,
are repeated in the narrative painting. The *composite figure*, which is a com-
bination of frontal views of the eye and torso with profile views of the head
and legs, is similar to Egyptian painting.

This version of Moche narrative painting is called *fineline painting* be-
cause of its thin, nervous contours. They are evident especially in the ex-
pressively rendered legs and feet, the sinuously curved inset or calf a hallmark
of Moche painting. With the stylized figures, the Moche artist communicated
speed. Runners holding bags of lima beans dash along the sand dunes, rep-
resented by the wavy, speckled ground. The Moche interest in setting is
unique in ancient American painting.

Moche artists were the experimenters in South America. Novel poses,
detailed settings, and episodic themes challenged their technical skills and
powers of visualization. Moche art is object oriented and action packed. The
subtleties of its symbolism are poorly understood because the Moche had no
writing, although some specialists postulate that they kept records on lima

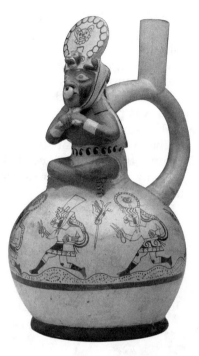

Figure 72 Moche, Peru. Messenger
stirrup-spout vessel, ca. 500; painted
clay, 10 1/2″ × 7 3/4″. Courtesy of The
Art Institute of Chicago

beans, hence the importance of the "bean messengers." Certainly the Moche
would have had difficulties transcribing theologies or histories, which would
explain the enigmatic ceramics, with such writing. Like many African, Oceanic,
and New World cultures, Moche traditions were preserved in oral histories.

CHIMU METALS

Around the year 1050, the Chimu culture replaced the Lambayeque cul-
ture, which had replaced the Moche in the northern coastal desert around 850.
The subjects of Chimu figurines, created in precious metals, are as intriguing
as the Moche narrative ceramics. Panpipes, flutes, and drums were associated
with the world of the dead, and Andean art shows the instruments played by
skeletons and humans. Music is related to the ancient American afterlife in a
manner that remains unclear, and in the next chapter we will see a similar
melody of death in Mesoamerican art.

The Chimu panpiper (Fig. 73) is a hollow silver statue with intricate stamped patterns. Andean smiths shaped jewelry, ceremonial weapons, figurines, and mummy masks by pounding flat sheets of precious metal over a form. Pieces were joined by wires, rivets, or solder. Greenstone accents the eyes in this example. The body proportions, similar to those in Moche art, and the simplified anatomy stem from an Andean tradition that found beauty in fabric. A body concealed was preferable to one revealed, and in ancient American art nudity was the sign of humiliation and defeat.

From their capital, Chan Chan, militaristic Chimu kings ruled a vast empire. In the fifteenth century they were reduced to vassals and their lands absorbed by the Incas, the only family to administer an empire of epic proportions in ancient South America.

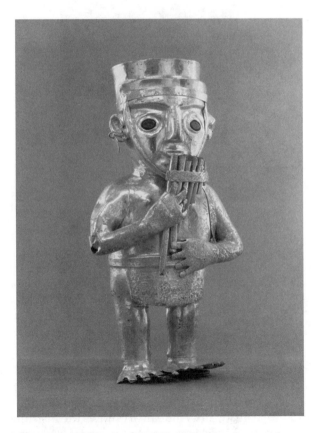

Figure 73 Chimu, Peru. Standing Musician, fourteenth and fifteenth century; silver, greenstone, 8 1/2″ H. The Metropolitan Museum of Art, New York

INCA ARCHITECTURE

In less than a century (1430–1525) the minor southern highland Inca clan built one of the largest empires in world history, consolidating three hunded eighty thousand square miles in Ecuador, Peru, Bolivia, Chile, and Argentina. Although the ethnic Inca comprised a small percentage of the population of six million, all Andeans owed allegiance to the Inca kings in their capital, Cuzco.

Unlike Cuzco, which has been continuously inhabited, the mist-shrouded, stone city of Machu Picchu (Fig. 74) was long abandoned when the romantic ruins were discovered in 1911. Only the buildings stood, silent reminders of the engineering genius of ancient American architects. The site, a narrow mountain ridge in the Andes, imparts great splendor to Machu Picchu. Buildings hug the terrain in a stunning synthesis of nature and architecture. It represents a sympathetic adaptation of human needs to the constraints of the natural environment. The city is surrounded by concentric rings of agricultural terraces cascading down the mountains like stone waterfalls. Levels of stone dwellings and sacred buildings, mazes of rooms built of carefully chipped granite blocks, rise from the granite mountains. With no ornamental vocabulary, Inca architecture tends toward refined functionalism. Its austere beauty is found in the materials, the construction, and the harmony of simple shapes.

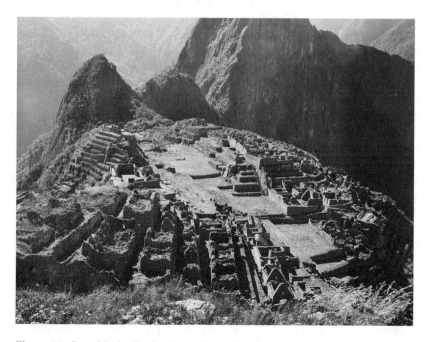

Figure 74 Inca. Machu Picchu, Peru, fifteenth and sixteenth century.

8

Mesoamerica

Mesoamerica (Middle America), a term with geographical and cultural implications, denotes the ancient civilizations that prospered on the narrow landmass between South America and North America. The major sites are clustered in the modern countries of Mexico, Guatemala, Belize, Honduras, and El Salvador.

The visual arts shed light on the vibrant if demanding lives led by ancient Mesoamericans. In their well-ordered societies hereditary professions of warrior, priest, farmer, and artist were clearly defined. Kings led their independent city-states in perpetual warfare, acquiring sacrifices to fertilize the earth. In art, militaristic subjects and pyramids, sites of ritual spectacle, were common. Art was a political tool, the themes of divine kingship and royal lineage particularly important. The exploits of a host of gods, the cosmic parallel to the human drama, were reported in art.

Some of what is known about ancient Mesoamerica derives from indigenous written languages composed of pictorial signs called *glyphs*. Names, dates, historical events, celestial phenomena, and some religious beliefs are documented in Mesoamerican writing. Observations made by Spanish explorers around the time of the Conquest (1521 in Central Mexico) provide information that is projected back in time to help explain cultures of remote antiquity.

FORMATIVE PERIOD

The foundations of Mesoamerican art and culture were laid in the Formative period (ca. 2000 B.C.E.–100). Monumental public architecture, divine kingship, mortuary art, and several gods emerged from the major sites to spread throughout Mesoamerica.

Olmec Civilization

The Olmec (1200–400 B.C.E.) is currently identified as the oldest sophisticated, sustained culture in Mesoamerica. The heartland of the seminal Olmec civilization was the tropical rainforest along the coast of the Gulf of Mexico. Although the Olmec had abandoned all the sites by 400 B.C.E., their achievements influenced Mesoamerican culture for the next two thousand years. The imposing architectural complexes of San Lorenzo, ritually destroyed around 900 B.C.E., and La Venta (900–400 B.C.E.) prefigure the platform mounds, open plazas, and cardinal alignment in Classic period design.

Stone carving was a forte of Olmec artists. Volcanic rock heads of prodigious proportions, which lined the courtyards of San Lorenzo and La Venta, and smaller statues of jade and stone are associated with Olmec sites. The Mesoamerica sculptural composition is ordinarily closed-form with the silhouette following the contours of the stone block.

Our small stone example (Fig. 75) is representative of Olmec aesthetics and iconography. Noteworthy are the seated man's columnar head, frontal position, fixed stare and open mouth. Although Christians believed similar Olmec statues to be the Virgin Mary and Christ Child, as they did

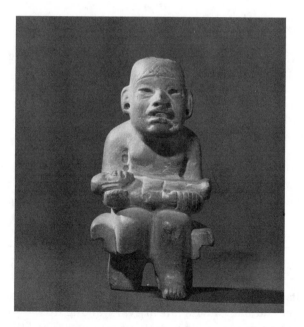

Figure 75 Olmec. Seated Figure with Baby, 1200–900 B.C.E.; stone, 4 3/4" H. The Metropolitan Museum of Art, New York

the Chinese Guanyin (Fig. 42), archaeologists interpret the pair as a young man holding an Olmec god. Several Olmec statues, in freestanding and relief formats, depict a similar pair with an authority figure presenting a baby to the audience.

The peculiar infant is the hallmark of Olmec art. It has been named the "were-jaguar baby" because it resembles a human transforming into a jaguar, as in "were-wolf." The stylized face has squinty eyes, snarling, mouth with fangs, and a rectangular, cleft forehead, the later associated with crocodiles. We can view the jaguar-baby as the Mesoamerican version of the Chavin Staff God (Fig. 69), both juvenile feline-reptilian-humanoid conglomerates.

Several theories have been proposed to explain the jaguar-baby. More intriguing than the simple suggestion that it represents a sacrifice are proposals incorporating Mesoamerican mythology and statecraft. For example, a Mesoamerican creation story relates that once humans and animals had been a single species, but a rift occurred, leaving only kings and shamans with the ability to communicate with animals. Perhaps the jaguar-baby was an emblem of Olmec kings who claimed shamanic powers or traced their ancestral line to the jaguar, the royal insignia in Mesoamerica. In another interpretation the jaguar-baby is the Rain God. If the enigmatic marks (perhaps proto-glyphs) that are found on other Olmec sculptures can be deciphered, the meaning of these works may yet be revealed.

West Mexican Ceramics

The character of West Mexican art and architecture suggests that the culture developed outside the sphere of Olmec influence. As the residents of West Mexico were predisposed to village life, large ceremonial centers and stone sculpture were not in their tradition, or remains have yet to be discovered in the parched environs. West Mexican culture is known by funerary goods recovered from communal mausoleums that originally may have been located under the ancient West Mexican houses. For decades grave robbers have been removing ceramics from the deep shaft tombs. Although the unfortunate recovery method has brought copious examples to light for our enjoyment, the lack of reliable documentation has impeded the study of West Mexican art.

Clay statues from the modern Mexican state of Nayarit constitute a unique Mesoamerican visual expression. They are multifigural tableaux of everyday activities that probably related to funerary events. At the ballgame (Fig. 76) two teams face off in the stadium. One team waits for the other to come out of its huddle, while spectators mill around in the stands. Bleacher bums, a mother and baby, and a late arrival walking up the steps add trivial details that strike a human note in Nayarit ceramics. The little solid figures, embellished with rolled and pinched clay, are positioned in an architectural context, giving us a three-dimensional photograph of ancient life.

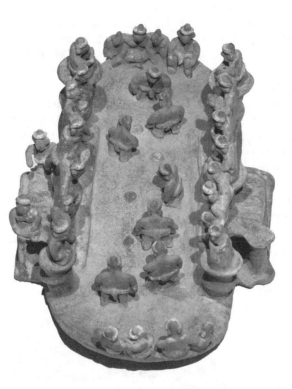

Figure 76 West Mexico (Nayarit). Ballcourt 100 B.C.E.–250; clay, 17 3/4 × 10 1/4". Yale University Art Gallery

CLASSIC PERIOD

The Classic period (100–900) was the golden age of great city-states, mighty warrior-kings, and brilliant artists. For a glimpse of the regional styles we will forage through the remains of two Classic period cultures, at the city of Teotihuacan and in the Maya territories.

Teotihuacan

Outside modern Mexico City are the ruins of the largest ancient city in the Americas, Teotihuacan, a bustling metropolis with cultural and commercial ties extending far beyond the urban boundaries. Unencumbered by fortifications, Teotihuacan spread over eight square miles, and at its peak the population numbered two hundred thousand.

Centuries after the city had been decimated by fire (around 650) and finally abandoned (by 800), the Aztecs named the ruins "The Place of the Gods."

They dubbed the heart of the city the Avenue of the Dead (Fig. 77), more accurately described as a series of courtyards establishing the north-south axis of the urban grid than a functional thoroughfare. Ceremonial and administrative precincts, temples, and palaces stood along the avenue in an integrated setting unique in ancient Mesoamerica.

Facing west at a right angle to the Avenue of the Dead is the oldest and largest building in Teotihuacan, the Pyramid of the Sun. It charted the rising and setting of the sun across its summit. The *platform mound* is a stone-faced, rubble and sun-dried brick mountain completed by the year 150. The Pyramid of the Sun and its companion at the north end of the avenue, the Pyramid of the Moon, are tiered platform mounds with single monumental stairways once leading to small temples of perishable materials. In their restored state, the tiers have smooth, sloping profiles. Several high status burials have been found under both pyramids.

The Pyramid of Quetzalcoatl, named for the Aztec feathered-serpent god, is another significant building at Teotihuacan. Unlike the Pyramid of the Sun, it was completed in two phases. The first Pyramid of Quetzalcoatl was

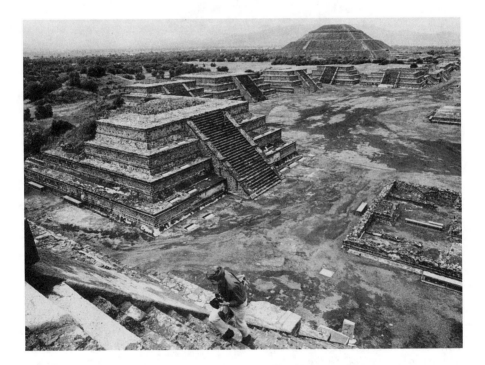

Figure 77 Teotihuacan (Central Mexico). Avenue of the Dead, view from the Pyramid of the Moon to the Pyramid of the Sun in the distance, first to seventh century

completed by 250, and sometime in the next one hundred fifty years it was encased in a larger, more "modern" pyramid. Most ancient Mesoamericans periodically renewed important buildings in this way, never demolishing the old building but preserving it intact as the core of the new structure. Consequently, old buildings are protected inside later ones. By removing outside layers archaeologists have found many examples of the delicately painted stucco sculpture that originally adorned the mounds.

Among the many exports from Teotihuacan were ceramics, mass produced to meet the needs of the large population, and for shipment to satellite territories. Molded and stamped components were assembled into puzzling assemblages such as the two-part incense burner (Fig. 78) with its classic Teotihuacan face staring from a thicket of flowers and birds. Efficiency enhanced output but did not hamper the creative potential of the ceramic medium.

The Maya

Another Teotihuacan export was obsidian, a hard volcanic rock used for weapons. Among their clients were the Maya (ancestors of the modern Mayan-speaking people), who occupied an area from the Guatemalan Pacific Coast north into the Yucatan Peninsula and west from Honduras into the Mexican state of Chiapas. Representational Maya art centered on the divine kings who ruled independent city-states and commissioned art for self-aggrandizement. Because Maya art is people–oriented in subject and naturalistic in style, it constitutes a unique visual expression in Mesoamerica.

Architecture, at Tikal. The Maya version of the platform mound is well represented in Tikal, the largest and most prestigious Maya city. The site had been occupied since 800 B.C.E., but the classic Maya city took shape in the fourth century of the current era when trading ties with Teotihuacan were established and Jaguar Paw (died 376) founded the long-lived Tikal dynasty. During the reign of Lord Chocolate (Ah Cacaw, 682–734) the city experienced a cultural surge.

In one of Tikal's nine ceremonial districts, architects designed two stately pyramids, Temple I (Fig. 79), Ah Cacaw's mortuary mound, and Temple II, which some specialists believe to be his wife's tomb. Certain features seen on Temple I are consistent with the Teotihuacan pyramids and others are distinctly Maya. The Maya stepped pyramid is compact, the proportions taller than its counterparts in Central Mexico. A steep stairway covering nearly one third of the frontal plane heightens the rapid ascent.

The stone-core, stuccoed pyramid is the platform for a three-room stone temple. Symbolically, the windowless building was a cave on the summit of the mountain, a sacred place to contact the divine ancestors. Crowning the temple is an elaborately carved stone *roofcomb*, an architectural element unique to Maya buildings. A roofcomb accentuated the height of the building and provided ample space for carved images. The entire surface of Temple I was

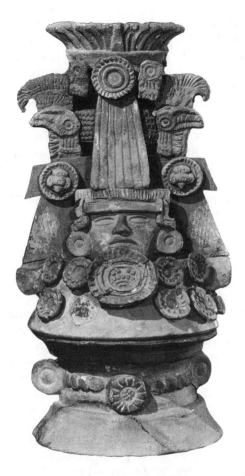

Figure 78 Teotihuacan (Central Mexico). Two-part incense burner, 300–650; painted clay. American Museum of Natural History, New York

painted; with its solid red pyramidal mound and multicolor roofcomb, the Maya temple was a brilliant jewel set in the jade-green forest.

 Sculpture, at Palenque. To begin a study of Maya figurative art we move deep into the rainforests to the ruins of Palenque, where the "Resplendent Persons," the glyphic title for Maya kings, traced their lineage to the creation of the world. Inscriptions begin the Palenque dynasty with God I, the First Father, and Lady Beastie, the First Mother, who shed her blood voluntarily to nourish the corn from which humans would be made. The dates are specific, calculated according to the Maya Long Count dating system. The First Mother was born December 7, 3121 B.C.E., and on August 13, 2105 B.C.E.,

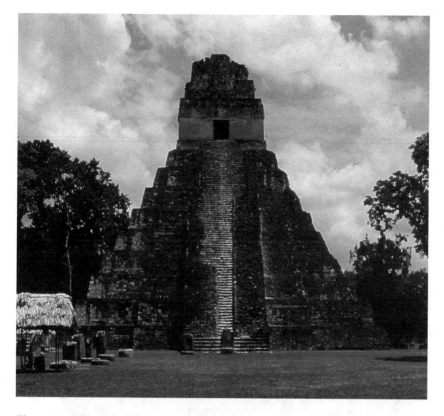

Figure 79 Maya (Tikal, Guatemala). Temple I, 727–734; stone and stucco, 144' H.

at the ripe old age of eight hundred fifteen, she became the world's first sovereign. The information conveys the feeling of specificity that pervades Maya art and the reality of myth in Maya thought.

What transpired in the remote past was a prelude to the accession in 702 of an historical king of Palenque, Kan-Xul (born 644). On the low relief limestone carving entitled the *Palace Tablet* (Fig. 80) he is shown accepting the emblems of power from his dead parents. His mother presents a war shield while the great Lord Pacal (603–683), the mightiest Palenque king and foremost patron of the arts, offers his son the tall jade crown. Kan-Xul's throne is a high-backed version of the Maya royal scepter, the *double-headed–serpent–bar*. Rows of glyphs record names, dates, and activities. Evidently the who, what, and when of history overshadowed the where in Maya reckoning, because the physical setting rarely interested Maya artists.

The Palenque trio is unlike any ancient American group we have encountered. Family members interact naturally, as though the dead parents

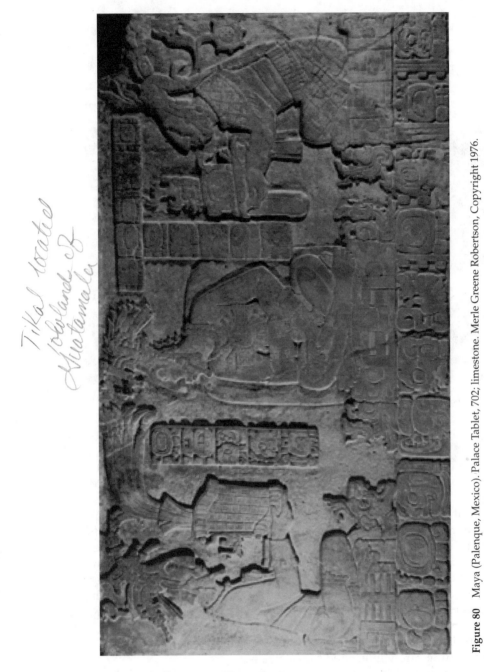

Tikal Isatio
Jowland of
Guatamala

Figure 80 Maya (Palenque, Mexico). Palace Tablet, 702; limestone. Merle Greene Robertson, Copyright 1976.

were giving their son last minute pointers on the art of administration, perhaps on the appropriate use of the ritual gear. Particularly arresting is Kan-Xul's attentive pose; he seems genuinely interested in what his father will say. His nonchalantly placed hands and the attention to other insignificant details, such as the soles of feet, contribute to the casual mood. The parents' bodies are excellently foreshortened, while the side view of the head allows for an advantageous display of the artificially molded Maya profile, achieved in life by binding boards to the infant's head. Unfortunately, Kan-Xul would not live to complete his tenure as king of Palenque. He was captured and sacrificed by his neighbor, the king of Tonina.

Codex-Style Painting. Maya artists were also masters of monumental mural painting and miniature paintings on ceramic mortuary vessels. *Codex-style* paintings, found on mortuary vessels, resemble pictures in illustrated Maya books, the latter an art form that has survived in pitifully few numbers. Codex-style paintings underscore the close ties between words and images in Maya art. Often the glyphs are integrated into the painting as costume ornaments or implements.

Linear codex-style paintings were ordinarily worked in brown paint on a cream ground with red accents on the rim, base, and a few passages in the composition. Brushwork possesses the calligraphic freedom of handwriting. Lines are springy marks with a so-called "whiplash flare." Because interior modeling was used sparingly, modulated contour lines convey weight and energize the design.

Codex-style painting has a nervous buoyancy, achieved by the line quality and the disposition of figures. In our example (Fig. 81), the prancing characters move with the freedom of Moche painting; symmetry and frontality have no place in Maya painting. Gyrating creatures fill the space from rim to base, rising on tip toes to reach into the glyphic inscription. Even the skeleton moves with a ballerina's grace.

Figure 81 Maya. Codex-style vessel, ca. 600; painted clay. The Metropolitan Museum of Art, New York

Now we face the herculean task of identifying the subject of this codex-style painting. No stranger to us is the chunky infant with jaguar paws and tail. In Maya cosmology, the jaguar-baby is usually associated with the sun and is often paired with Chac-Xib-Chac, a god connected with ritual decapitation. Chac-Xib-Chac is identified by his shell earspools and a fin on his cheek. He wields an axe in preparation for the jaguar-baby sacrifice. Accompanying Chac-Xib-Chac in his macabre dance is a bloated-bellied skeleton, the Death God. A dog, guide through the maze of death, waits expectantly for the new arrival. The sacrifice takes place atop a gaping mouth, the jaws to the Underworld.

From the Maya perspective this information made perfect sense. When the sun (jaguar-baby) sank below the horizon at night it entered the Underworld, a watery hell called *Xibalba*, ruled by despicable stinking creatures, the Lords of Death. The celestial event was a metaphor for human death. As surely as the sun rose in the morning, triumphant over the Lords of Death, the deceased Maya would rise to join the ancestors in the sky. Since the first Maya glyphs were deciphered by Tatiana Proskouriakoff in 1960, specialists have been slowly opening this world of Maya mythology.

Jaina Figurines. From the island of Jaina, located off the Campeche coast, comes another type of funerary item, miniature clay statues. Jaina, like Xibalba, was a watery realm on the western fringe of the Maya world, and people from across the Yucatan Peninsula sought burial there. Of the estimated twenty thousand graves on the island, slightly over one thousand have been opened.

Jaina figurines are musical instruments, whistles with a mouthpiece inserted in the back or rattles with pellets in the body. They were handbuilt or mold-pressed. The finest figurines combine the two methods, the heads always being mold-pressed. Mass production expedited the process, but the Maya style is naturalistic compared to the abstract creations of the Teotihuacan ceramic industry. Where they were made remains a mystery, because no clay deposits or kiln sites have been found on the island.

Warriors and priests, lords and ladies, captives and deities are among the subjects of Jaina figurines. Our ballplayer (Fig. 82) is suited in cumbersome protective gear, a *yoke* (wooden or leather circlet worn around the waist) and a *palma* (also called a *hacha*) inserted in the front of the yoke. A review of the Nayarit ballgame shows that the players were wearing identical uniforms five hundred years earlier. The position of the Jaina ballplayer's right arm, a gesture associated with respect or submission, may relate to the zigzag lines incised on the headdress, a motif found frequently on depictions of captives and penitents.

In the Mesoamirican ballgame, players bounced a solid rubber ball off hip, arm, or thigh onto the court walls. In many regions the object of the game was to propel the ball through rings mounted vertically on the walls. At the conclusion of the grueling contest, the captain of the losing team was sacri-

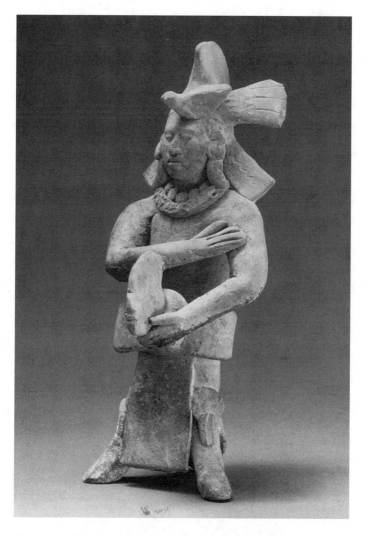

Figure 82 Maya (Jaina). Ballplayer, 600–900; painted clay, 3" H. The
Seattle Art Museum

ficed by heart extraction. The rules varied from region to region and proba-
bly the significance of the outcome as well. Maya specialists have interpreted
the ball as a symbol of the sun passing back and forth across the court.
Ballplayers sustained the solar rounds by nourishing the universe with their
blood.

Bloodletting, in rites of self-mutilation by Maya elite and in public sac-
rifices of war captives and ballplayers, is a recurring subject in Maya art. At

Palenque we saw that kings could go under the blade and on the codex-style vessel, the gods themselves. As archaeologists unravel the Maya story it is becoming clear that the constant fear of ritual death contributed to the collapse of the Maya kingdoms.

POSTCLASSIC PERIOD

The five centuries of the Postclassic period (900/1000–1521) were ones of imperial expansion in Mesoamerica, culminating in the meteoritic rise of the Aztecs. For style, iconography, and technical virtuosity, Aztec artists owed a debt to all the Mesoamericans who had preceded them.

Supposedly, the nomadic tribe arrived in Central Mexico in the early thirteenth century. Established communities tolerated the ragtag immigrants because they were accomplished mercenaries. With their ferocious battle skills, the Aztecs subjugated their neighbors and created an empire embracing over eleven million people. They terrorized Mesoamerica for territory, tribute and, above all, captives for the priests' blades in their capital city, Tenochtitlan. In temples atop the pyramids, living victims' hearts were extracted and their bodies cast down the great stairways.

Artists shared the responsibility of convincing the population that these activities were necessary. Sculpture explained the need for death in the cycle of life. The cohesion of the universe hinged on blood sacrifice, as essential to existence as the rising of the sun was to the cycle of days.

The monumental Sun Stone (Fig. 83), discovered in the sacrificial precinct of Tenochtitlan, states explicitly the rationale for human sacrifice. It

Figure 83 Aztec (Central Mexico). Sun Stone, ca. 1502; stone, 141 3/4" D. Museo Nacional de Antropologia, Mexico

is a cosmic calendar, a temporal counterpart to the Tibetan Buddhist cosmic map (Fig. 32). In the center of the radial composition is the sun on the horizon, the sun at the moment of destruction. It is about to be swallowed by the earth, shown with flint-knife tongue and claws holding sacrificial blades.

The Sun Stone foretells the exact day of the ultimate cataclysm, in the fourth month of the year, on Ollin (motion) day. The dying sun is encased in the Ollin glyph, a circle with four rectangular projections. In the rectangles are the dates of the previous solar annihilations. By Aztec calculations, they lived in the Fifth World, and it was their responsibility to delay disaster by appeasing the earth with blood sacrifice. The Aztec world ended in 1521 when Spanish conquistador Hernando Cortes led his own mercenaries into Tenochtitlan.

9

North America

The indigenous peoples of North America, whom we will call Native Americans, have had a special sensitivity for nature. Everything is potentially sacred and, therefore, deserving respect. A holistic worldview, an awareness of the interdependence of life, has shaped the Native American experience.

The belief in cosmic harmony accounts for many attitudes in Native American art. Life is a cooperative venture among people, animals, spirits, and the earth. Atmospheric spirits exist in the wind and clouds, terrestrial spirits in the mountains and streams. In contrast to Japanese kami, Native American spirits are interactive and seek humans; spirits on the Great Plains are said to have drawn their own pictures to attract people. From the Native American perspective, spirits do not reside in images although they are captivated by them.

Three themes predominate in Native American art; animals, war and mythic episodes of spirits and culture heroes. A kinship with animals has resulted in copious animal imagery and accouterments with animal motifs such as feathers and horns. Culture heroes are often zoomorphic (animal shaped), and spirits appear frequently in animal form. Art also affirmed social rank and clan affiliation, with special emblems designed for fraternal societies of warriors and charismatics. Art documented honorable deeds, helped ensure the community's livelihood, protected one from harm, and preserved personal health.

Before the establishment of reservations in the nineteenth century, Native Americans were a people in transit. Even those who built permanent dwellings and substantial towns practiced seasonal rounds or ventured some distance for provisions. Mobility encouraged cross-fertilization in Native

American cultures. Small scale, portable art was typical, and, in most instances, monumental stone sculpture and architecture were impractical. Attuned to the land, Native Americans responded with art and architecture tailor-made to the locale. Art was subject to the basic laws of nature, creation, and decay. Because the notion of transcending time was irrelevant, works were made of perishable substances.

Our brief survey of Native American art is divided into two parts; ancient art made before contact with Europeans and subsequent historic period art. *First Contact*, the phrase denoting a pivotal moment in the lives of indigenous peoples throughout the Americas, wrought profound changes on Native American cultures. Many ancient traditions continued into the post-contact era, but the art created after the sixteenth century grew out of encounters with a worldview vastly different from the Native American.

ANCIENT PERIOD, BEFORE FIRST CONTACT

From the time of their arrival in North America from Asia, postulated anywhere from 60,000 B.C.E. (a remarkably early date proposed by a Swedish specialist in Native American religions), to the more traditional date of 12,000 B.C.E., Native Americans responded well to their environment. By 8000 B.C.E. regional cultures had emerged in the Southwest and in the Woodlands, the territory east of the Mississippi River.

Woodlands

Adena Culture. An early Woodlands culture is named the Adena (1500/1000 B.C.E.–500) for a farm in the Ohio River Valley where important mounds have been excavated. Imposing *earthworks*, massive sculptural mounds of piled dirt, stand out at Adena sites. The world's largest representational (effigy) mound, Serpent Mound (Fig. 84), is located on a precipice one hundred feet above a creek. Because it appears to have a coiled tail and a mouth with an ovoid shape in it, the mound is interpreted as a snake devouring an egg or turtle. Possibly it was a *totem*, the tribe's animal ancestor.

As Serpent Mound was built over the centuries it transformed the landscape but did no environmental damage. The monument was neither visually nor ecologically intrusive. Since its massive scale made Serpent Mound invisible to the people who assembled there, it must have been the spirit of the place that was important. Perhaps Serpent Mound was a ceremonial site or a boundary marker on the edge of one tribe's territory. Amateur and professional excavators have sifted through every inch of dirt, but no burial goods have been found in Serpent Mound.

Mississippian Period. The Mississippian period (1000–1700) is the last phase of precontact Woodlands civilization. River valleys from Florida to Wisconsin supported Mississippian settlements. European explorers who en-

Figure 84 Woodlands (Adena). Serpent Mound, Adams County, Ohio, 1000 B.C.E.–400;
1247' L.

countered Mississippian people often chronicled their experiences, but they
rarely mentioned Native American art. Statues were always called "idols;"
the exotic costumes and customs interested the foreigners most.

The principal city in the urban-based Mississippian culture was Cahokia,
in southern Illinois. With a population estimated at fifty thousand, Cahokia
was the largest ancient city in North America. It was a regional administra-
tive center, a ritual complex and probably the home of a hereditary monarch
who ruled the city and surrounding towns, as the oni and oba had in Africa.

Within the walled city of Cahokia are conical burial mounds and earthen
platform mounds. The ceremonial district contains a north-south plaza and a
mammoth earthen mound, Monks Mound, a four-terraced, platform mound
that was renewed in several stages. Monks Mound supported a temple or
royal residence on its summit and smaller buildings on the lower levels. The
axial alignment and plaza-mound sequence recall Mesoamerican architecture,
but choosing earth over stone as a building material was in the Native
American tradition.

The low relief shell and copper sculpture and freestanding statues in
wood, clay, and stone, which are often recovered from Mississippian graves,

appear to have been possessions of the deceased rather than specially made mortuary goods. So many similar objects had been retrieved from southeastern Mississippian tombs that the style was named the Southern Cult (or Southeastern Ceremonial Complex). It is characterized by symbolic motifs including sun discs, cross-in-circle directional signs, serpents with feathers and horns, swastika-shaped wind signs, and warriors with bird emblems. Mississippian sculpture exhibits formal and iconographic continuity over a wide geographic area.

Many Mississippian objects are *gorgets*, neckpieces suspended on a cord passed through two perforations on the edge. A gorget (Fig. 85) is a shell disc with images etched in the surface. Our example is unusual for the number of pierced areas in the composition. Identical eagle-warriors stand in heraldic symmetry. The bent knees, typical of all eagle-warrior representations, have led to interpretations that the figure is running, dancing, or flying. Because the avian attributes are incorporated into the costumes, eagle-warriors were probably not supernaturals, like the Andean Staff God and Ocelot Being. Possibly they represented an exclusive group, a warrior class with a predatory bird totem. Perhaps the gorget is a surprisingly accurate rendition of Native Americans whom explorer Giovanni de Verrazano (1524) described as "clad in feathers of fowls of diverse hues."

Themes of nurturing are less frequent in Native American art. Male hunter-warrior subjects outnumber female agriculture-fertility motifs. The small effigy bottle of a nursing mother (Fig. 86), found near Cahokia, may have related to fecundity since vignettes of everyday life, such as the Nayarit tableau (Fig. 76), are absent in Native American art. When we compare it to

Figure 85 Woodlands (Mississippian). Gorget, 1300–1500; shell, 4 1/2" D. University of Tennessee

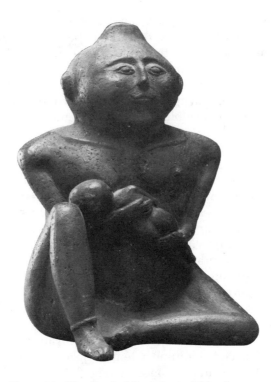

Figure 86 Woodlands (Mississippian). Nursing Mother Effigy Bottle, from Cahokia, 1200–1400; clay, 5 5/8" H. St. Louis Science Center

the Olmec sculpture (Fig. 75), the mood of the Mississippian pair seems intimate and less ceremonial. With its closed-form contour the stylized body is in keeping with the Native American penchant for abstraction. Although the figure is not quite 6 inches high, its simplified shape creates the impression of a monumental stone sculpture.

Southwest

The first inhabitants of the American Southwest lived in nomadic hunting and gathering bands. Significant changes occurred around 300 B.C.E. when Native Americans began to construct permanent dwellings, shape ceramics, and cultivate corn, beans, and squash. Villages of circular semisubterranean pithouses were the norms until around 700/900 when a change was made to aboveground rectangular dwellings.

Pueblo Architecture. Pueblo (town) architecture, named by Spanish explorers, is a hallmark of ancient Native American civilizations in the

Southwest. It represents the single instance of ancient Native American stone architecture.

Cliff Palace (Fig. 87) is one of over thirty pueblos in Mesa Verde, Colorado. By 1200, the canyon supported a population of about eight hundred, with three hundred people residing at Cliff Palace. The location, imbedded in a natural rock overhang, was inconvenient since water and farmland were far below on the canyon floor or above on the mesa. Defense probably motivated the mountain dwellers to choose the troublesome site.

Cliff Palace is a linked series of flat-roofed, rectangular rooms with adjoining walls. Ladders connected the three levels. Most activities took place in the open-air plazas rather than in the dark, stuffy interiors.

Underneath the plazas are circular structures called *kivas*. The multipurpose buildings were religious centers, men's clubs, and places for children's initiation rites. Interiors varied, but most kivas had spectator benches on the walls, a fire pit with a vertical deflector slab, and a *sipapu*, a small hole in the floor replicating an emergence spot. Emergence was the key idea in a kiva, the association preserved in the creation stories of Hopi people. As the audience descended a ladder through an opening in the kiva roof (plaza floor), it reenacted the myth of the heroic Two Brothers, who had climbed down a ladder through a hole in the earth to liberate primordial people imprisoned in the World Below.

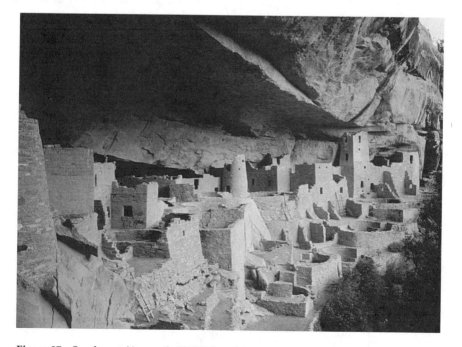

Figure 87 Southwest (Anasazi). Cliff Palace, Mesa Verde, Colorado, ca. 1200.

Cliff Palace was built by ancient people whom archaeologists have named the Anasazi. Their civilization was centered in the Four Corners Region of Arizona, Utah, Colorado, and New Mexico. Between 1300 and 1600 all the major Anasazi sites were abandoned, a sequence of devastating droughts believed to have contributed to their demise. Our understanding of the culture derives from the living traditions of their descendants, including the historic Hopi and residents of inhabited pueblos such as San Ildefonso, both of whom we will visit soon.

Mimbres Ceramics. The Mogollon people, ancient pueblo dwellers in the Mogollon Mountains of New Mexico and Arizona, are best known for their ceramics, named *Mimbres* after the river along which many examples have been found. Mimbres bowls are dated from 1000 to 1150, the fluorescence of Mogollon culture. It is unlikely that any more vessels will be recovered because looters bulldozed the ancient Mogollon villages in the 1960s and 1970s searching for marketable specimens.

A Mimbres bowl (Fig. 88) was a mortuary vessel placed over the head of the deceased. Before burial the vessel was ceremonially "killed" by breaking a hole in the center. Some specialists believe the kill-hole released the spirit of the vessel so it could accompany the deceased. Linear renditions of stylized animals and humans are painted in absolute symmetry inside the bowl. Thin lines along the rim define the picture plane and frame the composition. Multifigural compositions appear with less frequency than pairs of insects,

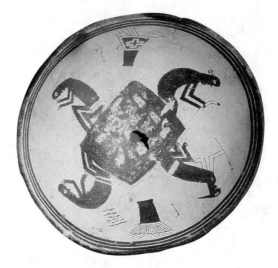

Figure 88 Southwest (Mogollon). Mimbres bowl, ca. 1150; painted clay. Maxwell Museum of Anthropology, Albuquerque

rendered in profile, and humans, presented in a frontal or composite view. The subject of our Mimbres painting has been interpreted as a weapons ceremony or the guardians of the four directions.

HISTORIC PERIOD, AFTER FIRST CONTACT

Many Native American traditions were experiencing serious disruption or had disappeared entirely by the time Europeans arrived. Their presence aggravated an already unstable situation, propelling the indigenous people into a new era; art helped keep the old beliefs alive.

Southwest

Ceramics. Despite the availability of imported porcelains, potters in the Southwest continued fashioning utilitarian vessels specially suited to native lifeways. In the early twentieth century, the beauty of these ceramics came to the attention of art collectors, and potters began working for the fine arts market.

In New Mexico the little pueblo of San Ildefonso was home to the premier Southwest art couple, Maria (1881–1980) and her husband Julian (1885–1943) Martinez. Most works were collaborative ventures with Maria shaping the vessels in the ancient handbuilt coiling method and Julian painting the motifs. Inspired by ancient potsherds unearthed near their pueblo, they revitalized Native American ceramics with innovative firing methods and new interpretations of ancient decorations, which were appreciated by their clients in the fine arts trade.

Maria is associated with a closed-fire firing process that forced carbon into the clay. To achieve the rich sheen (Fig. 89) she polished the unfired vessel with a stone before the designs were painted in a black matte slip. The lustrous reflective surface makes the satin patterns visible on the distinctive black-on-black "Maria–wares."

Hopi. The Hopi people, descendants of the ancient Anasazi, reside in Arizona pueblos. For hundreds of years they have performed dance ceremonies addressed to the *kachina*, spirits who assist people in living harmoniously with nature. Dances, performed by long columns of identically dressed kachina impersonators, begin in December and conclude in early July. Kachina impersonators wear elaborate costumes and imitate the mannerisms of specific kachina.

One way in which Hopi children learned to recognize individual kachinas was through colorful kachina dolls (Fig. 90). Men carved the figurines from lightweight cottonwood and painted them with the unique costume and mask of each kachina. The antiquity of the tradition is unknown, but some specialists have suggested that it was inspired by Spanish statues of Christian saints. In the twentieth century professional artists have made great numbers for retail sale. Because collectors prefer naturalism, the recent kachina stat-

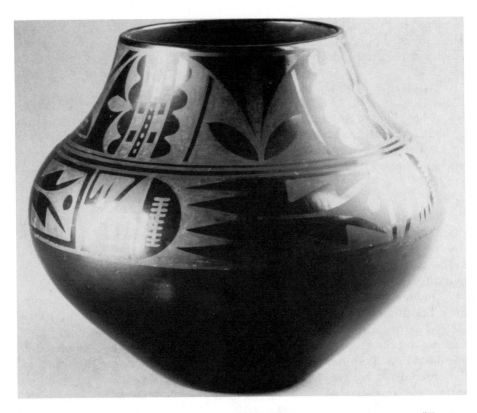

Figure 89 Southwest. Blackware vessel, by Maria and Julian Martinez, 1939; clay, 13" D × 11 1/8 " H. National Museum of Women in the Arts

ues are larger, livelier, and more detailed than the older, simpler, closed-form examples.

Navajo. The multimedia healing rituals of the Navajo of Arizona attract spirit assistants called the *Holy People* (*ye'ii*). The Navajo believe that sickness results from disharmony, and if they perform the ceremonies correctly, the Holy People will restore harmony to dispel illness.

A *drypainting* (sandpainting) is a component in long ceremonies of dancing and singing. It is made by people working under the supervision of a ritual specialist who diagnoses the illness and prescribes the cure. To create the picture, an individual mixes natural colors with sand which is then sifted through the fingers onto a smooth sand floor. For the duration of the ceremony the patient sits in the center of the picture. When competed, the drypainting is erased and the sand discarded outside the homestead. Drypaintings are impermanent because they are powerful instruments for summoning the Holy People; calling them unnecessarily is considered dangerous.

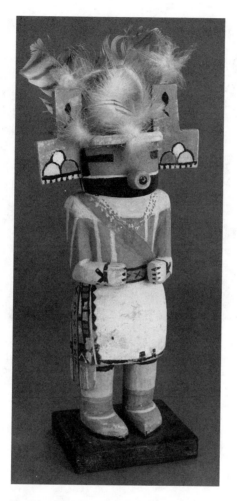

Figurine 90 Southwest (Hopi). Kachina
figurine, 1951; painted wood, feathers. The
Field Museum, Chicago

Whirling Logs (Fig. 91), one of nearly six hundred recorded Navajo dry-painting designs, is part of a nine-day curative ritual. Projecting from the center of the radial composition are stylized renderings of the four sacred plants, corn, beans, squash, and tobacco, painted in the symbolic directional colors. The Holy People, holding staffs and prayer bundles, are recognized by long slender bodies and blue sky heads, round for males and square for females. Their leader is Talking God, who carries his squirrel medicine bag. Rainbow Guardian circumscribes the space, but she leaves the east, the direction from which good comes, unprotected. In the Navajo style, gravity is dismissed and

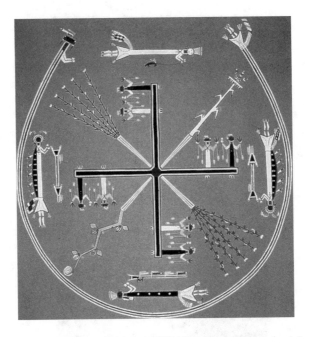

Figure 91 Southwest (Navajo). *Whirling Logs*, destroyed original drypainting approximately 6′ square; recorded in gouache on illustration board by Mrs. Franc (Arthur) J. Newcomb, before 1933; 22 5/8 × 28 3/4″. Courtesy of The Wheelwright Museum of the American Indian, Santa Fe

mass is diminished with flat color and sharp outline. Clarity, repetition, and balance embody the beauty sought by the Holy People.

Northwest Coast

Another unique Native American art style flourished along the northern Pacific coast in Canada and the United States. Among Native American communities, only the Northwest Coast supported full time, professional artists. Art thrived because the conspicuous display of goods affirmed social standing; the consumption of art stimulated the production of art.

Initially, the quality of life in native communities was enhanced by contact with Europeans. Native Americans became wealthy fur merchants, and the importation of metal tools advantageously affected the quality of sculpture. Fortunes declined after 1900, and art suffered miserably. Since midcentury, Northwest Coast art has experienced a renaissance.

In the abundant forests, artists found red cedar to create the paintings and carvings which are documented in a commercial photograph staged by the firm of Winter and Ponds around the turn of the century (Fig. 92). The items were created for the *potlatch* (competitive feasting) and for the enact-

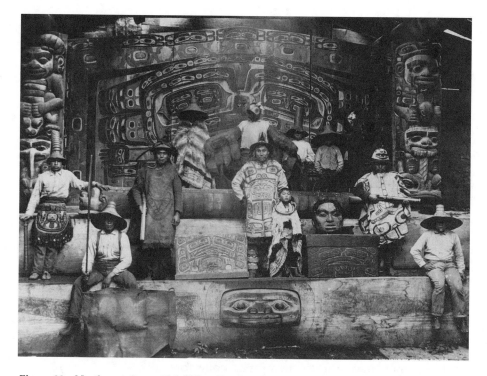

Figure 92 Northwest Coast. Chief Klart-Reech House interior, late nineteenth century; commercial photograph, by Winter and Pond. Alaska State Library

ment of ancestral myths. The man in the back left wears a tall potlatch hat with woven rings recording the number of potlatch feasts his clan has hosted. Two men in the front row wear clan hats with totemic animal emblems carved from cedar and inlaid with abalone shell. From shredded cedar bark and goat wool, women wove the ceremonial garments, also emblazoned with clan totems.

The wall is a painted *dance screen*, the stage set for dramatic performances of clan legends. The theatrical masks worn by the players are among the world's largest and most complex masks. *Transformation masks* were crafted with wooden animal parts that open and close like doors over a carved human face. No doubt, the two bird-masks in the back row had strings and hinges for that purpose.

Flanking the dance screen is a pair of *totem poles*, wooden columns carved with family crests composed of animals and humans interacting in a visual record of clan history. A totem pole is a vertical sculpture fashioned from a halved, hollowed cedar log. Poles were placed in many locations, freestanding in the town, in the burial grounds, on the exterior of houses, and inside a house, as our photograph shows.

Three-dimensional carvings and two-dimensional paintings share stylistic features in Northwest Coast art. The transformation of animals into humans and the resulting dislocation of parts creates spatial ambiguity. On the dance screen, faces and eyeballs appear in unexpected places, filling backgrounds, facial features, and limbs. A propensity for curved-corner rectangles is also evident in the two cedar chests in the foreground of the photograph. Frontality and *split representation*, a design strategy which divides an image in two equal flat halves, produce perfect symmetry. The final stylistic feature is the *formline*, a contour line that swells to become its own shape.

Woodlands

Iroquois. On the opposite side of the continent descendants of the pre-contact Mississippian warriors did not fare as well as the Northwest Coast merchants in their dealings with Europeans. Members of the League of Iroquois, a confederacy of five tribes, were consolidated on reservations in Canada and New York State. Military fraternities became defunct, but curative societies endured.

The Society of Faces, a medicinal fellowship, is an Iroquois masking society of considerable antiquity. Their masks, called *False Faces*, are mixed–media sculptures of wood, horse hair, and metal. Carvers were specialists but not professional artists. Although the Society of Faces is a living tradition, most masks are created for art collectors now.

False Face masks were inspired by personal visions of spirits, but they still exhibit remarkable homogeneity. The mask (Fig. 93) by twentieth century carver Elon Webster represents the most powerful False Face spirit, the Great Doctor. An Iroquois culture hero, the Great Doctor conveys healing powers to those who carve his image and give him tobacco. He acquired his crooked face in a test of strength with the Creator. According to the story, the Great Doctor challenged the Creator to a duel for control of the earth. They sat facing east while each tried to summon the Rocky Mountains. The Great Doctor moved the mountains slightly. Doubting that his rival had completed the task successfully, the Great Doctor turned abruptly, smashing his face into the mountains. The startlingly asymmetric design, a study in expressive distortion, communicates the theme of sudden impact. Deep undercutting creates mysterious shadows while the metal discs brighten the eyes.

Great Plains

When we visualize Native Americans it is probably the horse-riding, bison-hunting warriors on the grass fields of the Great Plains who come to mind first, yet historically their culture represents the last flowering of indigenous American traditions before revivalist movements of the twentieth century. From the diverse heritages of the Plains People a coherent artistic expression arose. Their requirements for good art are clear. It had to be trans-

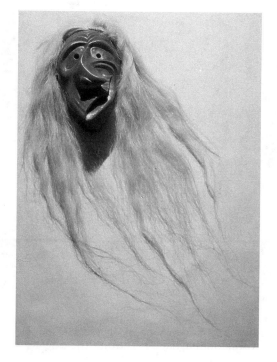

Figure 93 Woodlands (Iroquois). Great Doctor
False Face mask, by Elon Webster, 1937; painted
wood, metal, horse hair. Cranbrook Institute of
Science, Bloomfield Hills, Michigan

portable, for both nomadic hunters and semisedentary agriculturalists. It also
had to be personally emblematic. Art enabled an individual to publicize per-
sonal accomplishments. Anyone with an experience worth retelling was a po-
tential artist in the Plains communities.

The importance of personal experience was also evident in Plains reli-
gions. A unique aspect of all Native American religions is the role of visions
and dreams in formulating communal beliefs. The experiences of individu-
als who had direct encounters with spirits expanded or modified the core of
truths transmitted by oral traditions, ceremonialism, and images.

The decorated shirt in Figure 94 was the product of a late nineteenth
century Native American religious movement, the *Ghost Dance*, which arose
from the personal visions of a charismatic, Wovoka. He prophesied that a
prosperous, peaceful age was on the horizon; great ancestors would return
from the dead and Whites would disappear. Because the United States cav-
alry thought the communal dances (actually performed to induce personal
visions) were war dances, the Ghost Dance movement was suppressed.

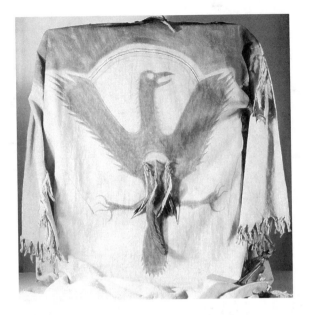

Figure 94 Great Plains. Ghost Dance shirt, late
nineteenth century. Museum of the American Indian,
New York

Representational *visionary style* paintings and *geometric style* beadwork
were methods for embellishing Ghost Dance shirts. In Plains societies vi-
sionary painting was traditionally the men's style and geometric beadwork
was the women's. In men's painting each episode, spatially unrelated to the
others, validated a vision or a heroic military encounter. Protected by the
spirit visions, in this instance the mythic Thunderbird, the wearer believed
himself to be impervious to bullets.

Men and women could paint, but only women created beadwork. By
the mid-nineteenth century decorations in seed beads, tiny glass trade beads,
had replaced the older technique of quillwork, which had used flattened por-
cupine quills and shell beads. Plains painting underwent technological
changes also, when lightweight cotton cloth replaced the cumbersome bison
skins used for earlier paintings. In both instances, the introduction of foreign
imports often benefitted the Native American artist.

FROM SPECIMEN TO ART

We concluded our first chapter with a note on the impact that African
art had had on European modernism, and a similar statement can be made
about Native American art. Initially, Western collectors considered Native
American works to be relics of primitive cultures, holdovers from a savage

state that Western civilization had progressed beyond. Objects were shown in an anthropological setting alongside stuffed animals and dinosaur bones.

In 1942 the prestigious Museum of Modern Art in New York City held a major exhibition introducing the modern art community to Native American art. European surrealists were especially interested in the dream imagery, and soon American painters of the Abstract Expressionist movement were drawn to Native American ideas. Jackson Pollock acknowledged his debt to Navajo drypainting. Since the 1950s imagery and methods have continued to inspire twentieth century artists. The monumental earthworks of Michael Heizer are impressive examples.

Artists in the lands we have visited in this book continue to create works of art incorporating traditional ideas, often using culturally based aesthetics and imagery for personal expression. While many civilizations have disappeared, the experiences preserved in works of art endure.

Glossary and Pronunciation Guide

For the pronunciation of vowels, the following system is used.

ey, in pr*ay*er *o h*, in *o*pen
a h, in f*a*ther *o o*, in b*o o*t
e e, in b*e e* *u*, in c*u*t
e, in b*e*t
ay, in p*ie*
i, in p*i*t

Aboriginal Australians Indigenous people of Australia
abstraction Universal art style that employs distortion without loss of imagery
Adena (ah.DEE.nah) Ancient Native American culture centered in Ohio, 1500/1000 B.C.E.–500
adobe Sun-dried mud bricks
adze Axe with blade positioned at a right angle to handle
Akbar (AHK.bahr) Mughal emperor, reigned 1556–1605
Akhenaten (AHK.he.NAH.ten) Pharaoh during the Amarna period, reigned 1378–1362 B.C.E.
akua ba (ah.KOOAH.bah) Asanti statue of an infant
album leaves Loose paintings in a portfolio
Allah Arabic word for "God"
Amarna period (ah.MAHR.nah) Brief period of revolutionary art in ancient Egypt
ambulatory Continuous walkway

Anasazi (ah.nah.SAH.zee) Ancient Native American civilization in the
 Southwest
Andean Region west of Andes mountains, and cultures there
Angkor Ancient capital of Khmer empire
Angkor Thom City within Angkor
aniconic Art without figural depictions of humans
animism Belief that life forces inhabit inanimate objects
anthropomorphic Having a human shape
Anyang (ahn.yahng) Last capital city of Chinese Shang dynasty
Aryans Nomadic people who invaded ancient India
Asanti (ah.SHAHN.tee) A West African people in Ghana
Ashikaga (ah.shee.KAH.gah) Era in Japanese history, 1338–1573
Ashoka (ah.SHOH.kah) Indian emperor, reigned 269–232 B.C.E.
Asmat (AHS.maht) Indigenous people of Irian Jaya
asymmetric Composition with an unequal distribution of elements on either
 side of the central axis
attributes Objects that identify a character
avatar (AH.vah.tahr) Reincarnation of a Hindu deity
Avenue of the Dead Plaza-road in Teotihuacan
axial Elements arranged in a straight line
Aztec Last ancient civilization of Mesoamerica; also the people

backstrap loom Andean weaving device
Banpo (bahn.poh) Chinese neolithic town
beadwork Fiber arts technique that embellishes a surface with beads of glass
 or shell
Benin (be.NEEN) Medieval West African kingdom in Nigeria
Bhagavad Gita Hindu scripture about Krishna
bhakti (bhuk.tee) Personal devotion to a Hindu deity
bi (bee) Chinese circular disc
black-on-black ware Ceramics with black decorations on a black ground
block-color style Andean fiber arts style
blue-and-white ware Glazed ceramics with blue decorations on a white
 ground
bodhisattva (boh.dhee.SAHT.vah) A Buddha-to-be
boneless style Colorful Far Eastern painting style without lines
Brahma (BRAH.mu) Hindu creator god
Brahman (BRU.mun) In India, the World Soul
brocade print Polychrome woodblock prints
the Buddha Enlightened One
Buddhism Asian religion founded in India
burnish In ceramics, to polish with a stone

Cahokia (cah.HOH.kee.ah) Mississippian city in southern Illinois
caste Social rank in India

Chac-Xib-Chac (chahk.sheeb.chahk) Maya god of decapitation
chaitya (CHAYT.yah) Buddhist assembly hall; also a type of Indian arch
Chamunda (chah.MOON.dah) Hindu goddess
Chan (chahn) Form of Buddhism, combining Buddhism and Daoism
Chan Chan Capital of Chimu empire
chanoyu (chah.NOH.yoo) Way of Tea; literally, "hot water of tea"
Chavin (chah.VEEN) Early Andean civilization, ca. 1000–300 B.C.E.
Chimu (CHEE.moo) Ancient Andean civilization in Peru
Chola period (CHOH.lah) Era in Indian history, 846–1250
Churning of the Milk Ocean A Hindu creation story
Classic period Era in ancient Mesoamerican history, 100–900/1000
closed-fire Firing technique that smothers the pottery
closed-form Composition with little or no interaction of space and shape
cloud collar Chinese decorative motif
codex-style Maya painting style resembling pictures in books
coiling Handbuilt ceramic technique using spiralling clay ropes
colonial period Era of European domination in Africa
composite figure Combined frontal and profile views of human body
Confucianism Ethical code of social behavior in the Far East
Confucius Chinese philosopher (551–479 B.C.E.)
conical mounds Cone-shaped burial mounds
cowrie shell Small, oval shell used as currency in several cultures
Cuzco (KOOZ.koh) Capital of Inca empire

dance screen Painting behind a Northwest Coast theatrical performance
Daoism (daow) Asian philosophy originating in China
Death God A Maya god of the Underworld, one of the Lords of Death
decorative style Painting style of Chinese Tang dynasty, also a style of
 Japanese screen painting
dharma Cosmic law, in India
Dogon (DO.gahn) A West African people of Mali
double-headed-serpent-bar Maya royal scepter
Dravidians Indigenous people of India
Dreamings Aboriginal Australian stories of the supernaturals
drypainting Painting technique using no binder with the pigments

eagle-warrior Mississippian militaristic figure with bird emblems
earth tones Colors from natural materials, especially reds, browns, yellows
earthenware Ceramics of fairly coarse clay
earthworks Huge sculpture made of dirt
Eccentrics Late Chinese painters who did not follow conventional styles
Edo (E.doh) Modern Tokyo
effigy Representational

False Faces Masks worn by Iroquois Society of Faces
fei-i (fey.ee) T-shaped Chinese silk
filial piety Respect for parents
fineline painting A style of Moche painting
First Contact Arrival of Europeans in the Americas
flanges Projecting spines on Chinese bronze vessels
foreshortening Compressing a shape to create an illusion of depth
Formative period Early phase of Mesoamerican culture, ca. 2000 B.C.E.–100
formline In Northwest Coast art, a line with shape
Four Corners Region Arizona, Utah, Colorado, New Mexico
freestanding Sculpture carved on all sides
Fumeripits Culture hero of Asmat

Gandharan (gahn.DAH.hrahn) An Indian art style
garbhagriha Literally "womb chamber," the sanctuary in a Hindu temple
Gautama A name of the historical Buddha
Genghis Khan Leader of the Mongols (1162–1227)
geometric style Great Plains style without representational imagery
Ghost Dance Nineteenth century Great Plains religious movement
glyphs (glifs) Mesoamerican writing form
God I The First Father god of Palenque
gorget (GOHR.jit) Pendant worn around the neck
grain pattern Chinese decorative motif of tiny raised dots
Great Doctor Iroquois culture hero
Great Goddess Hindu female deity, composite of all other female deities
Great Plains Territory east of the Mississippi River and north of the Rocky
 Mountains, excluding Four Corners Region
Great Pyramids Three monumental mortuary mounds in Africa
Guanyin (guwahn.yin) Chinese bodhisattva of compassion
Gupta (GOOP.tah) Classic Indian art style

haboku (hah.BOH.koo) Japanese wet ink painting
Han dynasty (hahn) Era in Chinese history, 202 B.C.E.–220
handscroll Long horizontal painting format
haniwa (HAH.nee.wah) Japanese mortuary figurines
Harappan (hah.RAH.pahn) Ancient Indian civilization, ca. 2300–1750 B.C.E.;
 also called *Indus Valley Civilization*
Heian period (HEY.ahn) Era in Japanese history, 897–1185
Heiankyo Capital city during Heian period
heraldic symmetry Two identical images facing each other or facing
 forward
hermaphrodite Having male and female sexual organs
Hideyoshi (hee.dee.YOH.shee) Japanese ruler (1536–1598)
Hinayana Buddhism (hi·nah·YAH·nah) "The Lesser Vessel" A form of
 Buddhism that recognizes only the historical Buddha; also called *Theravada*

Hindu Indigenous polytheist religion of India
Holy People Supernaturals among the Navajo
Hopi (HOH.pee) A group of historic Native Americans in Southwest
horror vacui An aversion to blank spaces
Hui Zong Last emperor of Northern Song (reigned 1101–1125)

ibeji (ee.BEY.gee) Yoruba statue of an infant
Ichikawa Family of Kabuki actors
Ife (EE.fey) Medieval West African kingdom in Nigeria
Immortals Supernaturals in Chinese popular Daoism
Inca Empire in South America; also the people
Indonesia Islands off the southern coast of continental Asia
inkstick Compressed ink and glue rubbed on an inkstone
Irian Jaya (iree.ahn.JAY.yah) Western half of New Guinea
Iroquois Historic Native Americans in the Woodlands
Islam Monotheist religion founded by Muhammad in the seventh century

Jaguar Paw First king of Tikal (died 376)
Jaina (HAY.nah) Island necropolis in Gulf of Mexico
jataka tales (JAH.tah.kah) Stories of the former lives of the Buddha
Jayavarman II (jah.yah.VAHR.mahn) Cambodian king (died 850)
Jayavarman IV Cambodian king (reigned 1181–1219)
Jomon (JOH.mohn) Neolithic period in Japan, ca. 11,000–300 B.C.E.

Kabuki (kah.BOO.kee) A form of Japanese theater
kachina (kah.CHEE.nah) Spirits among the Hopi; also a figurine
Kali (kah.lee) Hindu goddess of destruction and death
Kamakura period (kah.mah.KOO.rah) Era in Japanese history, 1185–1333
kami (kah.mee) Spirits in Shinto
Kan Xul (kahn.shool) A king of Palenque (born 644)
Kannon Japanese bodhisattva of compassion
karma Action and consequence
key block Alignment block in woodblock printing
keyhole-shape mound Japanese burial mound
Khamerernebty Wife of Old Kingdom pharaoh, Menkaure
Khmer (KHOO.mer) A people of Cambodia
kiva (KEE.vah) Semisubterranean sacred building in a pueblo
Kofun period (KOH.foon) Era in Japanese history, 300–600/710
Kota (KO.tah) An African people in Gabon and Cameroon
Krishna (KREESH.nah) An avatar of Hindu god Vishnu
Kuba (KOO.bah) An African people in Zaire
Kubilai Khan Mongol emperor of Chinese Yuan dynasty (reigned
 1260–1294)

Kushan (koo.SHAN) Indian empire, 50–320
Kushite (KOO.shayt) Ancient Nilotic civilization in Africa

La Venta Olmec ceremonial site
Lady Beastie First Mother goddess of Palenque
Lao Zi Chinese philosopher, credited with ideas in Daoism
League of Iroquois Federation of five Iroquois tribes, including Mohawk and
 Seneca
Liao (lee.aow) Tartar people in China
Lokeshvara (loh.kesh.VAH.rah) Bodhisattva of royalty
Long Count dating Maya dating system
Lord Chocolate (Ah Cacaw) Maya king of Tikal
Lord Pacal Maya king of Palenque (603–683)
lotus position Pose with feet on thighs
low relief In sculpture, shapes raised slightly from a background
Luba (LOO.bah) An African people in Zaire
lyrical style Southern Song poetic landscape painting

Mahayana Buddhism (mah.hah.YAH.nah) "The Greater Vessel," a form of
 Buddhism that recognizes multiple buddhas
Maitreya (may.TREY.ah) A bodhisattva, Buddha-of-the-Future
mandala (mahn.DAH.lah) Buddhist or Hindu diagram of universe
mandapa (mahn.DAH.pah) Assembly hall in a Hindu temple
manuscript illumination Painting in a book
Maori (MOO.ree) Indigenous people of New Zealand; as an adjective,
 MEY.o.ree
Mathuran An Indian art style
Maya (MAY.yah) Mayan-speaking Mesoamericans
mbis Asmat spirit poles
meditative garden Zen contemplative garden
Menkaure (Mycerinus, in Greek) Old Kingdom Egyptian pharaoh
Mesoamerica Central America
mihrab (MEE.rahb) Niche in a mosque
Mimbres Ceramics created by Mogollon people
mimi (mee.mee) Spirits among Aboriginal Australians
Minamoto Yoritomo First shogun (1147–1199)
minaret Islamic tower for announcing prayers
Ming dynasty Era in Chinese history, 1368–1644
Ming Huang Chinese Tang dynasty emperor (reigned 712–756)
Mississippian Era in ancient Native American culture, east of the Mississippi
 River, 1000–1700
mixed–media Many different materials in one work of art
Moche (MOH.chey) An ancient Andean people, also called *Mochica*
 (moh.CHEE.kah)
Mogollon (MOH.goh.yahn) An ancient people in American Southwest

Mohenjo-daro (moh.hen.joh.DAH.roh) Harappan city
moksha In Hindu, cessation of rebirths
Momoyama (moh.moh.YAH.mah) Era in Japanese history, 1573–1615
Mon Indigenous people of Thailand, also called *Dvaravati*
Mongols Nomads who invaded Asia in the thirteenth century
Monks Mound Major platform mound at Cahokia
monochrome painting Chinese ink painting
monotheism Belief in one god
monumental style Northern Song grandiose monochrome landscape
 painting
mosque Islamic religious building
Mount Meru (MEY.roo) The world mountain
mudra (MOO.drah) Meaningful hand gestures in Indian art
Mughal dynasty (MOO.gahl) Islamic empire in India, 1526–1857
multimedia Incorporating sound and motion in the work of art
multiple-block sculpture Wooden sculpture using several pieces of wood
mummy bundles Andean burial form
Mumtaz Mahal Wife of Mughal emperor, Shah Jahan
Murasaki Shikibu Author of *Tale of Genji*
Muslim A follower of Islam

Nandi (NAHN.dee) Bull vehicle of Shiva
narrative painting Painting that tells a story
Native Americans Indigenous people of North America
Navajo (NAH.vah.hoh) Historic era Native Americans in Southwest
Nayarit (nay.yah.REET) Modern state in Mexico
neolithic Stone technology-based cultures
Nilotic (nay.LAH.tic) Ancient African cultures along the Nile
nirvana In Buddhism, cessation of rebirths
Nok Ancient West African culture in Nigeria, 500 B.C.E.–200
nonrepresentational Art style with no recognizable imagery
Non-Western General term for cultures that matured with little or no
 influence from the West
Northern and Southern dynasties Era in Chinese history, 265–581
Northern Wei (wey) Kingdom of the Toba Wei in China
Northwest Coast Cultural region along Pacific coast, Oregon to Alaska
Nubia (NOO.bee.yah) Ethnographic area in east African Sudan

oba (OH.bah) Title of the god-kings of Benin
Oceania Islands in the Pacific Ocean
Ocelot Being Descriptive name for an Andean deity
Ollin Aztec day-name
Olmec (OHL.mek) Early Mesoamerican civilization, 1200–400 B.C.E.
one-corner Ma Asymmetric designs in Chinese landscape painting

oni (OH.ney) Title of the god-kings of Ife
overall composition A design with no focal paint, fills surface evenly

pagoda Version of the Buddhist stupa
Palenque (pah.LEN.key) Ancient Maya city in Mexico
palma Part of equipment worn in Mesoamerican ballgame
Paracas (pah.RAH.kahs) Andean culture, ca. 1400–1 B.C.E.
Parvati (pahr.VAH.tee) Consort of Hindu god Shiva
personification Idea represented in human form
pharaoh Title of the god-kings of ancient Egypt
pithouse Circular or rectangular dwelling, partially underground
platform mound Flat-topped pyramid
plaza Open-air courtyard
pleasure garden Japanese decorative garden
polychrome Many colors
polytheism Belief in many gods
popular Daoism Chinese religion with Immortals, also called *religious Daoism*
porcelain Glazed fine-clay ceramics
portrait vessels Moche vessels in the shape of a human face
potlatch Ceremonial feasting
Principles of Chinese Painting Six necessary elements, compiled in late fifth century
Postclassic Final era in precontact Mesoamerica, 1000–1521
pueblo Town of rectangular stone dwellings with adjoining walls
Pyramid of the Sun Name of two American mounds, largest platform mound in Teotihuacan and largest platform mound in South America (Moche)

Qin dynasty (chin) Era in Chinese history, 221–206 B.C.E.
Qin Shih Huang Di (chin.shir.huang.dee) First emperor of China (259–210 B.C.E.)
Qing dynasty (ching) Era in Chinese history, 1644–1912
Quetzalcoatl (ket.zahl.koh.AHTL) Aztec feathered-serpent god
quillwork Fiber arts technique that embellishes a surface with porcupine quills
Qur'an Islamic scripture (also *Koran*)

Radha Beloved of Krishna
radial composition Visual elements projecting from a center point
Rainbow Guardian Border of a Navajo painting
Rainbow Serpent Aboriginal Australian creator spirit
Rajput (RAHJ.poot) Hindu prince, also a painting style
rarrk Aboriginal Australian patterns
rath Literally "chariot," a Hindu temple form
reliquary Holder for sacred objects (relics)
roofcomb Vertical stone slab on top of a Maya building

samsara Rebirths; reincarnations

samurai Japanese gentleman-warrior

screen Japanese painting format, fixed or portable

seed beads European manufactured glass beads

Sen Rikyo (sen.REE.kyoh) Japanese tea master (1522–1591)

Shah Jahan Mughal emperor of India (reigned 1627–1658)

Shakyamuni (shahk.yah.MOO.nee) Honorific title of the historical Buddha

shaman Person with powers to contact spirits

Shang dynasty (shahng) Era in Chinese history, 1766–1045 b.c.e.

Shino ware (SHEE.noh) Type of Japanese pottery associated with tea ceremony

Shinto (SHEEN.toh) Indigenous religion of Japan

Shiva (SHEE.vah) Hindu god, the "Destroyer"

shogun Japanese military dictator

Shotoku Prince who fostered Buddhism in Japan (574–622)

Siddhartha A name of the historical Buddha

sipapu (SEE.pah.poo) Emergence hole in a kiva

Society of Faces Iroquois fraternity of healers

Song dynasty Era in Chinese history, divided into Northern Song, 960–1127, and Southern Song, 1127–1179

Southeast Asia Mainland Indochina and Indonesian Islands

Southern Cult Mississippian art with a unique set of symbols; also called *Southeastern Ceremonial Complex*

sphinx In Africa, human head on a lion body

split representation Flattened shape with two identical sides

Sri Lakshmi (shree.LAHK.shmee) Hindu goddess of wealth

Staff God Descriptive name for an Andean deity

stirrup-spout vessel Andean ceramic shape

stupa (STOO.pah) Indian reliquary mound

sub-Saharan African cultures south of the Sahara desert

Surya (SOOR.yah) Hindu sun god

symmetric Composition with an equal distribution of elements on both sides of the central axis

Taharqa (tah.HAHR.kah) Kushite king (died 664 B.C.E.)

Tale of Genji (GEN.gee) Japanese novel, ca. 1000

Tales of Ise (EE.sey) Japanese poetry collection, ca. 950

Talking God Leader of Navajo Holy People

Tang dynasty (tahng) Era in Chinese history, 618–906

tanka Meditative, magical painting

teahouse Japanese building reserved for tea ceremony

Teotihuacan (tey.oh.tee.hwah.kahn) Largest ancient Mesoamerican city

Three Jewels of Buddhism The Buddha, the Law, the monastic community

Three Perfections In Chinese culture, poetry, calligraphy, painting

thunder pattern Chinese decorative motif of square spirals

Tikal (tee.KAHL) Ancient Maya city in Guatemala
Tiy (tay) Mother of pharaoh Akhenaten
Toba Wei Group of Turkish people in China
tokonoma Alcove in a teahouse
Tokugawa Ieyasu (ee.YAH.soo) Founder (1542–1616) of the Tokugawa period
Tokugawa period (toh.koo.GAH.wah) Era in Japanese history, 1615–1868;
 also called *Edo*
totem Clan's mythological animal ancestor
totem pole Wooden column with clan emblems
transformation mask Mask with moveable parts combining animal and
 human elements
triple-flex pose Position of the human body in Indian art
Two Brothers Hopi culture heroes

ukiyo-e (yoo.kee.YOH.ey) Literally "floating world pictures," depictions of
 Japanese entertainments
underglaze painting In ceramics, painting before glaze is applied
urna (UR.nah) Mark on forehead, a sign of enlightenment
ushnisha (oosh.NEE.shah) Protuberance on top of head, sign of
 enlightenment

Vedas Sacred scriptures in India, initiated by the Aryans
Vedic period Era of Aryan domination in India, ca. 1750–500 B.C.E.
vedika (VEY.di.kah) A fence
Vishnu (VISH.noo) Hindu god, the "Preserver"
vision quest Personal search for the supernaturals in Native American
 cultures
visionary style Great Plains painting style inspired by personal contact with
 supernaturals

Way of Tea Japanese tea ceremony
were-jaguar baby Descriptive term for Olmec human-jaguar child
Western, the West General term for cultures descended from Greece
womb chamber Sanctuary in a Hindu temple
woodblock print Printing process using a wooden matrix
Woodlands Territory east of the Mississippi in North America
Woot Mythical founder of Kuba kingship, also Mukenga
worldview Communal attitude about life, its meaning and structure
Wovoka Founder of Ghost Dance religion

Xibalba (shee.BAHL.bah) Maya Underworld

yakshi (YAHK.shee) Indian female nature spirit
Yamato Japanese imperial family
Yamato-e Japanese-style painting
Yan Guifei Consort of Chinese Tang emperor, Ming Huang
yang In Daoism, the active force of nature
Yangshao (yahng.shaow) Chinese neolithic culture, ca. 5000–2000 B.C.E.
ye'ii (YEYee) Navajo word for supernaturals
yin In Daoism, the passive force of nature
Yingarna A Rainbow Serpent
yoke Equipment worn in Mesoamerican ballgame
Yoruba (YOH.roo.bah) A West African people in Nigeria
Yoshiwara (yoh.shee.WAH.rah) Entertainment district of Edo
yu (yoo) Chinese ritual vessel
Yuan dynasty (yoo.ahn) Era in Chinese history, 1279–1368

Zen Form of Japanese Buddhism
Zhou dynasty (joh) Era in Chinese history, ca. 1045–256 B.C.E.
Zhou hooks Decorative motif in ancient Chinese art
zong Chinese hollow cylinder
zoomorphic Assuming the shape of an animal

Bibliography

ALDRED, CYRIL, *The Egyptians*. London: Thames and Hudson, Ltd 1984.

BERLO, JANET CATHERINE and LEE ANNE WILSON, *Arts of Africa, Oceania, and the Americas: Selected Readings*. Englewood Cliffs, NJ: Prentice Hall, 1993.

CARUANA, WALLY, *Aboriginal Art*. London: Thames and Hudson, 1993.

COE, MICHAEL D, *The Maya*. London: Thames and Hudson, 1991.

CORBIN, GEORGE A., *Native Arts of North America, Africa, and the South Pacific: An Introduction*. New York: Harper and Row, Publishers, 1988.

CRAVEN, ROY C., *Indian Art: A Concise History*. London: Thames and Hudson, 1991.

FEEST, CHRISTIAN F., *Native Arts of North America*. London: Thames and Hudson, 1992.

FISHER, ROBERT E., *Buddhist Art and Architecture*. London: Thames and Hudson, 1993.

GILLON, WERNER, *A Short History of African Art*. New York: Viking Penguin, 1986.

KUBLER, GEORGE, *The Art and Architecture of Ancient America*. London: Penguin Books, 1990.

LAPIDUS, IRA M., *A History of Islamic Societies*. Cambridge: Cambridge University Press, 1993.

LEE, SHERMAN E., *A History of Far Eastern Art*. Englewood Cliffs, NJ: Prentice Hall, 1982.

MASON, PENELOPE, *History of Japanese Art*. New York: Harry N. Abrams, 1993.

MEYER, LAURE, *Black Africa: Masks, Sculpture, Jewelry*, trans. Helen McPhail. Paris: Terrail, 1992.

MILLER, MARY ELLEN, *The Art of Mesoamerica from Olmec to Aztec*. New York: Thames and Hudson, 1990.

NABOKOV, PETER and ROBERT EASTON, *Native American Architecture*. New York: Oxford University Press, 1989.

RAWSON, PHILIP, *The Art of Southeast Asia: Cambodia, Vietnam, Thailand, Laos, Burma, Java, Bali*. London: Thames and Hudson, 1990.

RICE, DAVID TALBOT, *Islamic Art*. London: Thames and Hudson, 1991.

ROWLEY, GEORGE, *Principles of Chinese Painting*. Princeton, NJ: Princeton University Press, 1974.

STANLEY-BANKER, JOAN, *Japanese Art*. New York: Thames and Hudson, 1984.

SULLIVAN, MICHAEL, *The Arts of China*. Berkeley: University of California Press, 1984.

TOWNSEND, RICHARD F., *The Aztecs*. London: Thames and Hudson, 1992.

TREGEAR, MARY, *Chinese Art*. London: Thames and Hudson, 1987.

TAYLOR, JOHN H., *Egypt and Nubia*. Cambridge: Harvard University Press, 1991.

WILLETT, FRANK, *African Art*. London: Thames and Hudson, 1985.

Index

Works of art and illustration numbers are in *italics*. Artists' names are in **boldface**.